LANDSCAPES IN
WATERCOLOUR

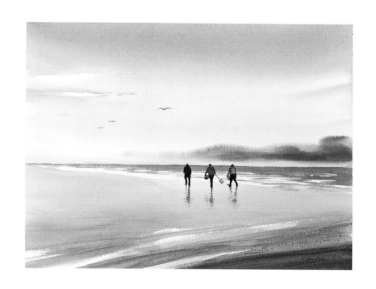

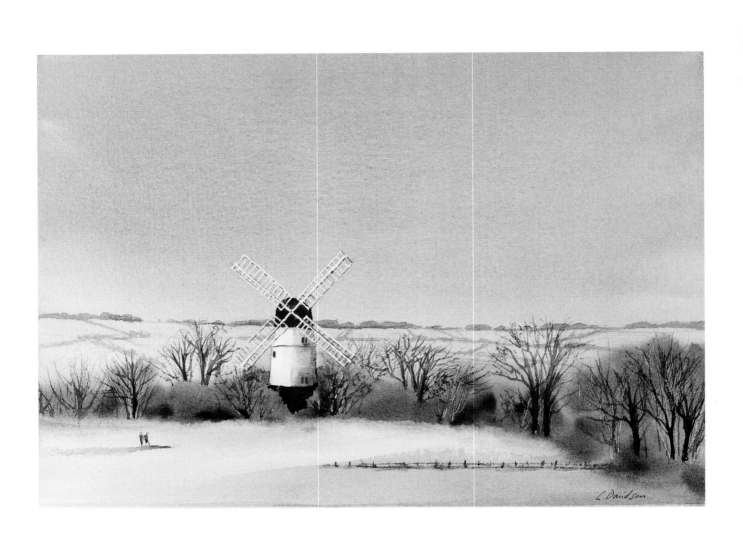

LANDSCAPES IN
WATERCOLOUR

TECHNIQUES AND TUTORIALS
FOR THE COMPLETE BEGINNER

LOIS DAVIDSON

First published 2024 by
Guild of Master Craftsman Publications Ltd
Castle Place, 166 High Street, Lewes,
East Sussex, BN7 1XU, UK

ISBN 978 1 78494 683 8

PUBLISHER **Jonathan Bailey**
PRODUCTION MANAGER **Jim Bulley**
SENIOR PROJECT EDITOR **Tom Kitch**
EDITOR **Theresa Bebbington**
MANAGING ART EDITOR **Robin Shields**
PHOTOGRAPHY **Lois Davidson and Scott Teagle**

Set in Baskerville
Colour origination by GMC Reprographics
Printed and bound in China

This book is dedicated to my parents, Eileen
and Rikki Davidson, who taught me all I needed
to know about art without me realizing it, and to
my daughter Morgaine, my greatest work of art.

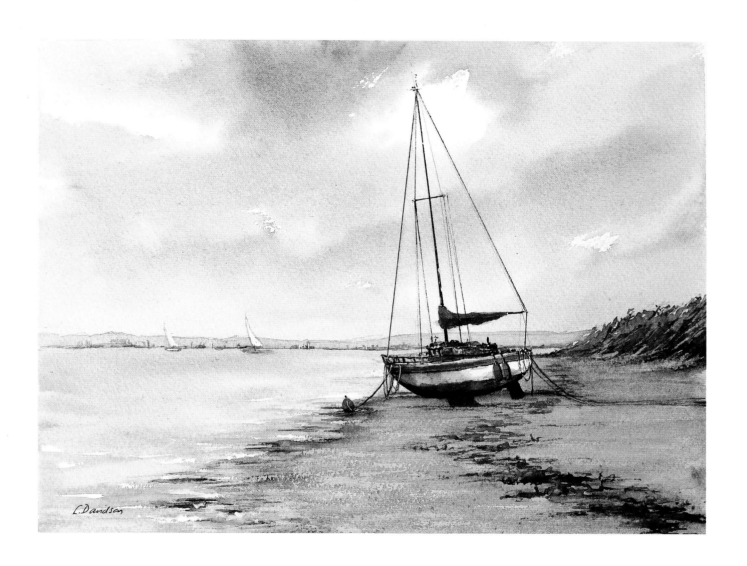

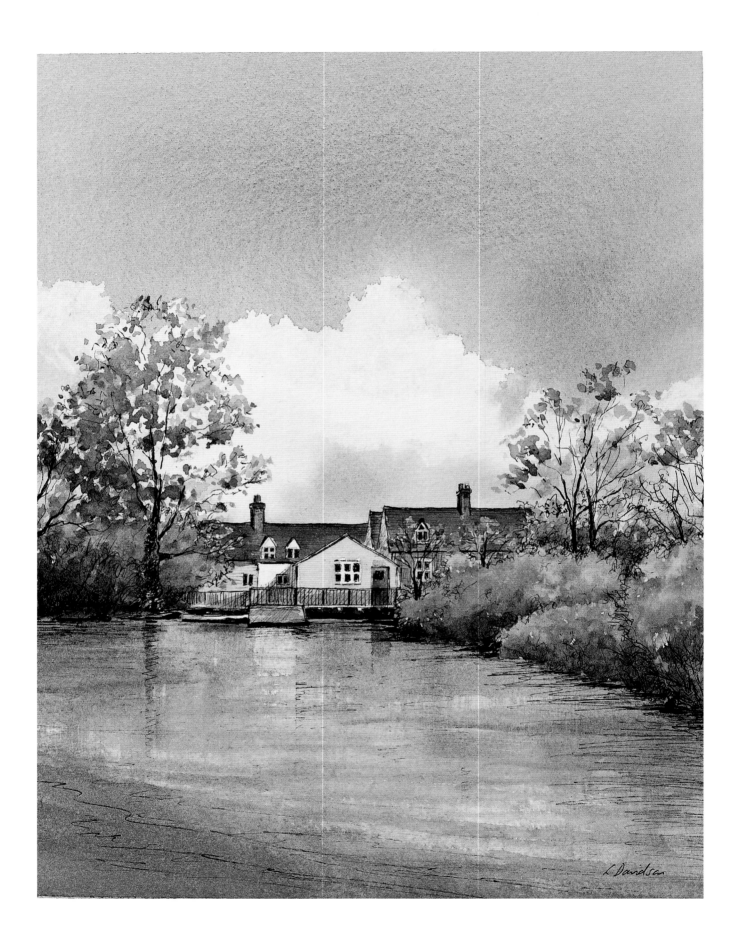

L. Davidson

Contents

Introduction

There is something magical about watercolour. This can be seen in the translucency of the medium, the way light can shine through transparent washes, and the subtle mingling of water and paint. It is an alchemy of sorts, and one that has captivated me unlike any other creative medium.

I have spent my life, on and off, drawing and sketching. It was only in 2018 that I took up watercolour seriously, after trying it for the first time and immediately falling in love with it. My background in drawing has heavily influenced the style of landscapes I enjoy painting. Whether I use pure watercolour or work in line and wash style, I find that simple sketches are the best foundation to underpin the washes of colour that follow.

In this book, you will find enough information and, I hope, enough inspiration to get you started on a watercolour journey. A fledgling painter will find the techniques and tools section at the start of this book invaluable to study before embarking on the ten watercolour landscape projects that follow. You do not need to adhere to these projects in any particular order, as watercolour itself is a medium that encourages flexibility and intuitive painting. Most importantly, remember to relax and enjoy the process. Every painting you create is one more step in your own journey.

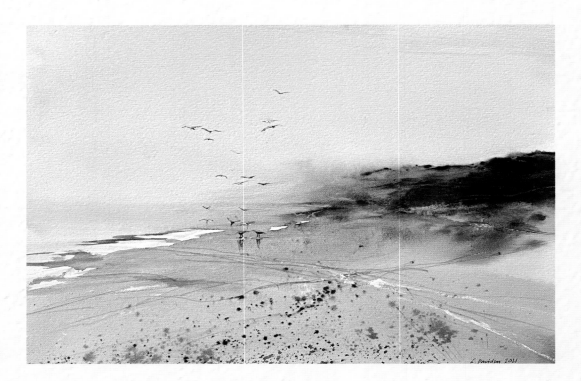

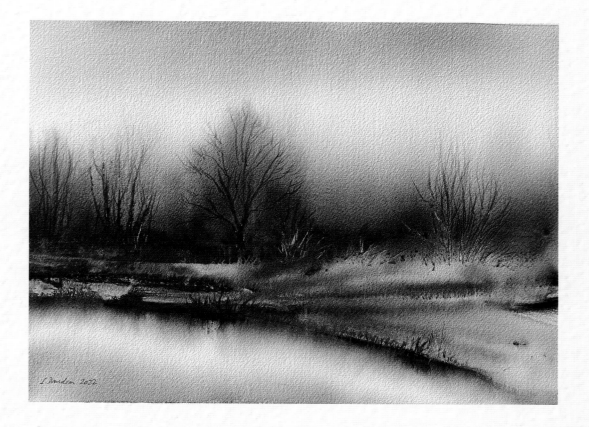

Be sure to take time to experiment, and practise what you've learnt or wish to improve on between projects, too. The more you do, the more you learn – and sometimes, making mistakes is what leads us to discovering something new and exciting along the way. Your own interpretations of my projects are likely to look different to the images you'll see printed here, which is no bad thing! This book is about learning the basics of watercolour landscape painting, as well as mustering up both the confidence and skill to begin painting in your own unique way.

Equipment and Materials

When presented with the huge variety of watercolour art supplies available, selecting the right materials and equipment can be an intimidating process for beginners. In this section, you will find advice to help clarify your choices and give you a good starting point to work from.

Watercolour paint

When it comes to watercolour paint, there are two grades: student quality and artist quality. Artist quality paints generally have a higher, purer pigment load but can be expensive. Student quality paints often carry more filler to bulk them out, but they are less costly. I recommend using student quality paints while learning, as they are cheap enough to use freely while you practise and experiment. It's worth waiting for sales at art stores to find bargains.

TYPES OF PAINT

Watercolour paint is available in two different varieties: fresh, in metal tubes of various sizes; or in the form of small, dried cakes of paint in plastic 'pans' that come in full or half sizes. These pans

pans are sold dry and need to be wetted with clean water before use to reactivate the pigments within.

Paints squeezed fresh from tubes mix easily with water to create vibrant colours. They can also be squeezed into empty pans or the wells in a paint palette and allowed to dry, and then be treated in the same way as pan paints. When wetting up pans of dried watercolour paint, I find it best to lightly wet the surface of each pan you want to use with a water spritzer or brush about 10 minutes before you plan to paint. This allows the dry paint enough time to wet up, so that it is ready to use.

MY PAINT COLOURS

The colours below are those I will be using for the projects in this book. You don't have to use these precise colours – you can use anything similar. Most watercolours are transparent whereas white gouache is opaque.

Tip

I prefer to purchase my paints as individual tubes or pans rather than in pre-curated selections. This way, I am buying the colours I know I will use. Novice painters often find that when they buy a large set of paints, they end up favouring only a small handful of colours and barely using the rest.

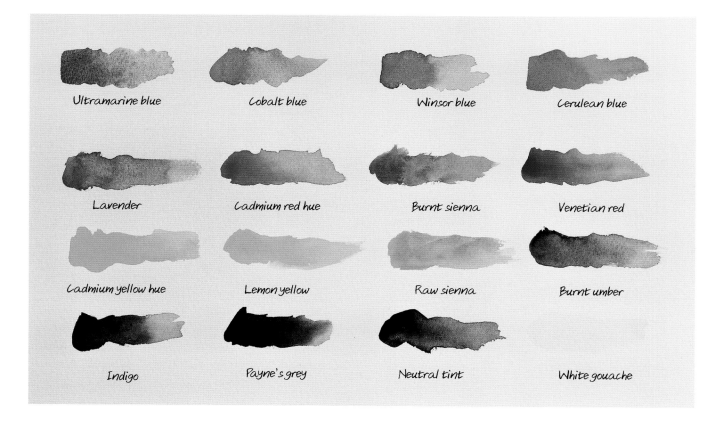

Ultramarine blue	Cobalt blue	Winsor blue	Cerulean blue
Lavender	Cadmium red hue	Burnt sienna	Venetian red
Cadmium yellow hue	Lemon yellow	Raw sienna	Burnt umber
Indigo	Payne's grey	Neutral tint	White gouache

Brushes

The enormous range of brushes available from most art suppliers can seem confusing to start with. However, you won't need one of each variety to paint the projects in this book: a few classic types of brush will serve you perfectly well.

You will be using mostly medium and large brushes that will enable you to cover the paper with fewer brushstrokes, which will help keep the washes looking fresh and transparent, as well as prevent the addition of too much detail too soon. The general idea is to paint most of the composition loosely with large brushes. You can then use smaller brushes to pick out a few details to pull the painting together.

The brushes you will need for the projects are:

1 1½in (35mm) mottler brush
2 No. 14 mop brush
3 No. 14 and no. 4 round brushes with good points
4 ¾in (19mm) flat brush
5 No. 2 rigger or liner brush
6 Small fan brush

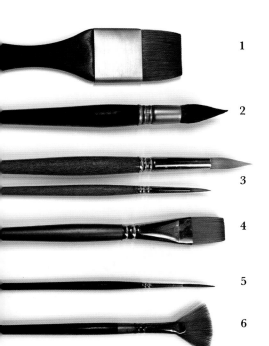

1½IN (35MM) MOTTLER BRUSH

The mottler brush is a great wash brush for holding a lot of paint and water, which means you will need fewer strokes to paint larger areas such as skies and stretches of water. Its versatile shape means that you can also turn it slightly to use the tip and corners for painting finer lines as well as landscape features such as rocks.

NO. 14 MOP BRUSH

Mop (or quill) brushes hold a lot of water and paint and release it slowly and evenly. This makes them ideal for large washes. When used with drier paint mixes, they can create lovely dry brush effects for delicate objects such as twigs and foliage when the belly, or flat side, of the brush is scraped over the texture of the paper (see pages 88 and 89).

Mop brushes are available to purchase in a full range of sizes from small to large. The medium size mop we use in the projects is a very good all-rounder.

¾IN (19MM) FLAT BRUSH

The thin shape of the flat brush makes it ideal for painting geometric elements such as walls, roofs, cliffs and rocks. The corner can be used for smaller rock and stone shapes, and the tip for crisp, fine lines. The brush tips can also be used to sweep paint from side to side to create effective ripples and reflections when painting water.

NO. 14 AND NO. 4 ROUND BRUSHES WITH SHARP POINTS

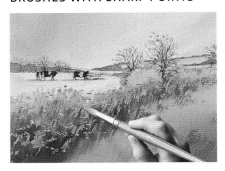

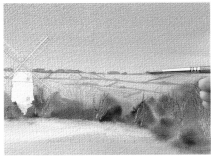

Round brushes with sharp points are versatile. The shape allows you to use them for a variety of tasks, from using the whole brush to create large wash-style brushstrokes to using the tip to make a range of interesting marks.

NO. 2 RIGGER BRUSH

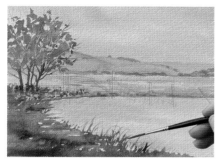

Designed for painting a ship's rigging, the rigger, or liner, brush has long, springy hairs that hold enough paint to create fine unbroken lines. This is useful for elements such as thin tree trunks and branches. It can be a little awkward to control, as the hairs are especially fine and springy; so, do test it out before committing to your final painting.

SMALL FAN BRUSH

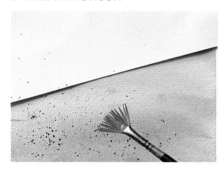

The fan brush is useful for foliage, grass and other natural shapes. But the main reason I like it is because it also creates a lovely patterning of spattered dots. To do this, fill it with paint that has the loose consistency of ink, then hold the fan over the painting and tap the brush with your forefinger, so that it releases a spatter of tiny droplets in the desired area. This can be done using the wet-in-wet technique, to produce an array of diffused, soft-edged patterns. It can also be used with the wet-on-dry technique to produce small, crisp spatter marks.

Paper

Watercolour paper is generally made from cotton rag or cellulose pulp. It comes in three types of surface: hot press, cold pressed (which is sometimes known as NOT) and rough. This describes the texture of the surface of the paper. Hot press has a very smooth texture and is often used for detailed work such as botanical paintings or portraits. Cold pressed (NOT) has a medium grain texture; and rough, as the name suggests, has a rough texture. Rough is often used for landscape painting, but the heavy texture takes a bit of getting used to, which is why I recommend cold pressed paper as a good all-round surface to begin with. All projects described in this book will be using cold pressed paper.

Watercolour paper also comes in a variety of different weights and thicknesses. Thinner or lighter weight paper will tend to buckle when wet. To prevent this, you can pre-stretch your paper (see right). I prefer to use 140lb (300gsm) weight paper as it doesn't need pre-stretching; and while it will expand and buckle a small amount as you paint, it will generally flatten back out as it dries.

You can purchase watercolour paper as pads, gummed blocks or loose sheets cut to size. Artists tend to have their own preferred type of paper, so it is best to try a few different types and brands yourself to determine which you prefer to work with.

The projects in this book are all painted on 11 x 15in (28 x 38cm) sheets, but this size is not a prerequisite for these paintings – you can use any size paper you feel comfortable working on. I recommend 9 x 12in (23 x 31cm) as a good size for beginners.

Tip

If you decide to pre-stretch your paper, soak it for a few minutes in clean water, then sponge off the edges slightly so that the tape will adhere. Tape to a board with gummed brown paper tape – you can buy it specifically for this purpose. Leave to dry. Once dry, the paper should remain flat as you paint.

Paint palette

There are many types of palettes suitable for mixing watercolour paint. These days, most are made from plastic, but you can also find some made of enamel or porcelain. They come in all sorts of shapes and sizes. If you buy a curated box of paints, they will often come in a paint box with mixing wells in the lid.

I favour a fairly large palette for landscape painting, as I often mix up large washes for skies, etc., so I recommend one with good sized wells. I use a palette with a lid, as this keeps my paint fresh for longer, and dust free.

Tip
If your palette doesn't have a lid, you can keep it in a zip-lock bag or pouch, which can be purchased cheaply from stationery supply shops.

Other equipment

For these projects you will be using masking tape to secure the watercolour paper to a painting board, which will then be set on an adjustable table easel. If you don't have an easel, work on a table with the top end of the board propped up at a low angle between 20 and 30 degrees. You can achieve this simply by using a couple of books under the top end of the board to raise it.

PENCILS
I use HB or B pencils for sketching and for drawing simple outlines on the paper in preparation for painting.

MASKING FLUID
You can use masking fluid either before painting to preserve the white paper or mid-painting to protect dry colour from subsequent washes.

FINELINER PENS
I use waterproof black fineliner pens in varying thickness of nib for the line drawing in my line and wash paintings. I recommend having 0.3mm, 0.5mm and 0.7mm pens for these projects.

WHITE GEL PENS
White gel pens and white acrylic ink pens are handy for highlights.

PALETTE KNIFE
You can use a palette knife to scrape through damp paint to reveal highlights and texture, or to apply paint. You can also use the corner of an old credit card or your fingernail for the same results.

GUMMED BROWN TAPE
If you pre-stretch your paper, you will need gummed brown paper tape.

SANDPAPER
To add texture or highlights at the end of a painting, you can use a piece of sandpaper or an emery board to lightly sand dry paint.

SPONGES AND TISSUES
It's a good idea to have a sponge to remove excess water from your brush after you have rinsed it. In addition, absorbent tissues or kitchen paper are great for lifting paint (for example, to create clouds), cleaning up any spills and removing excess water from brushes.

RULER
Rulers are useful for precise straight lines, such as the horizon. We use the ruler in the Flatford Mill project (see pages 80–85) to ensure the line work for the reflections is accurately placed.

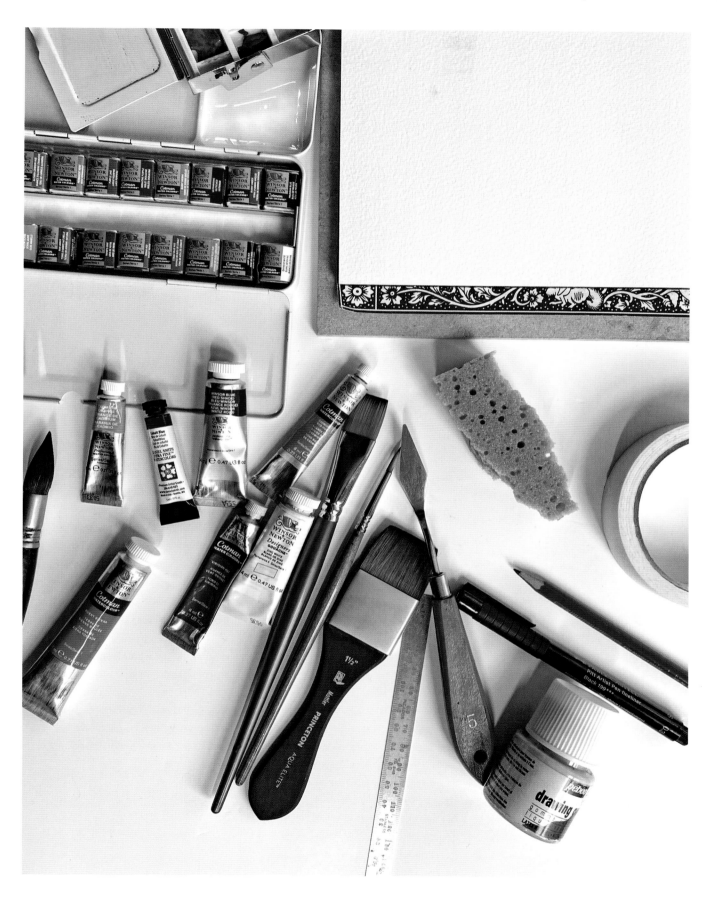

Colour and Value

Using colour theory and the idea of tonal values are important considerations when composing a painting. Colour brings your work to life, and value adds depth and dimension.

Colour theory basics

Colour theory is a fascinatingly complex subject, but understanding the basics can help you to achieve harmonious and dynamic results in your painting.

PRIMARY COLOURS

The three primary colours are red, blue and yellow. You can make any colour by mixing the three primaries using varying quantities of each.

SECONDARY COLOURS

The three secondary colours are green, orange and violet. A mix of two primaries will make a secondary colour: yellow and red will make orange, blue and yellow will make green, and red and blue will make violet.

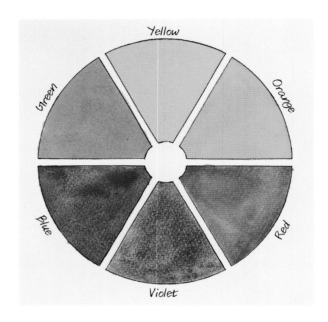

COMPLEMENTARY COLOURS

The secondary colours are also known as complementary colours; each primary colour has a complement that can be mixed from the other two primary colours. So, the complement for red is green, made from a mix of blue and yellow; the complement for blue is orange, and the complement for yellow is violet.

Complementary colours contrast with or 'complement' each other, and placing one next to the other can really make an object in a painting pop. For example, a bright orange buoy against the blue hull of a boat or in blue (or grey) water will really stand out and draw the viewer's eye. It is a great way to lead the viewer to a point of interest in a painting.

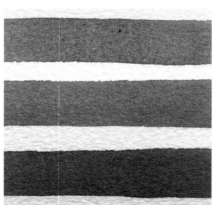

NEUTRALS, BROWNS AND GREYS

As well as including brighter colours, landscape painting relies heavily on subdued neutrals to create natural-looking scenes. You can easily mix wonderful neutral colours by de-saturating brighter colours with a touch of Payne's grey or neutral tint, and you can create a good range of browns and greys by mixing differing amounts of each of the three primary colours.

WARM AND COOL COLOURS

Colours can be classified as either warm or cool, and these colour temperatures can affect the overall atmosphere of a painting. Warm colours tend to stand out and come forward, so they are good for foregrounds or points of interest. Cool colours will recede, making them perfect for distant hills and mountains.

Red and yellow are warm and blue is cool, but individual colours will have warm or cool versions. For example, cerulean blue is considered cool as it has slightly greenish undertones, whereas ultramarine blue is considered a warm blue as it contains reddish undertones.

Value

Tonal value refers to the lightness or darkness of tones, e.g. how dark or pale a colour is. It adds contrast and dimension as well as depth and distance to a painting and can help guide a viewer's eye towards points of interest.

The more water you add to a paint mix, the paler it will become and the lighter the value will be. Conversely, less water added to the paint, the deeper the colour will be and the darker the value. Finding the right tonal value comes through practice with trial and error.

The swatches above show the dark, mid and light tonal values for ultramarine blue.

I've converted the ultramarine blue swatches to black and white to clearly show the value shifts.

FINDING THE TONAL VALUES IN A REFERENCE PHOTO

There are various ways to work out the tonal values within a reference photo, but I find this method is one of the simplest. Start off by converting your colour image to black and white – this enables you to see the tonal values without being distracted by the colours. The first values to look out for are the lightest parts of the scene. For example, in this beach scene, they are the sky and some of the rocks, which I left unshaded in the sketch. Then, observe which areas are mid-value. Here, we can observe that the sea and most of the foreground beach in the photograph are a mid-value, so we can use light shading to define these areas. Finally, locate the darkest areas. For this scene, they are parts of the distant headland and some areas of beach. We can block out these areas using a black fine liner as shown.

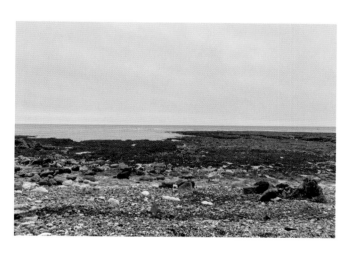

Try squinting at the photo so the details become blurry – this focuses on the tones instead of the details.

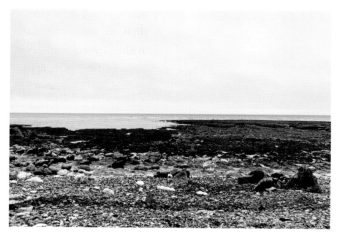

I converted the image to black and white in my phone's photo editor, a very useful way to find the values.

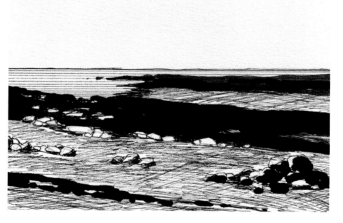

I simplified the scene into the main tones, leaving out most of the details and refining the composition.

Composition

At its simplest, composition comes from the choices you make about what to include and exclude in a painting, and how to arrange your chosen elements on the paper in a visually pleasing way.

The 'rule of thirds' is a common principle that can be a useful guide for planning out a composition. Think of the paper as a grid divided into nine equal parts. The points where the grid lines intersect are generally considered to be a good place to position a point of interest or 'focal point'. Placing your main subject on or around one of those points, then enhancing it with a little more detail and definition, can create more visual interest than simply placing the focus in the middle of or along the edge of the paper.

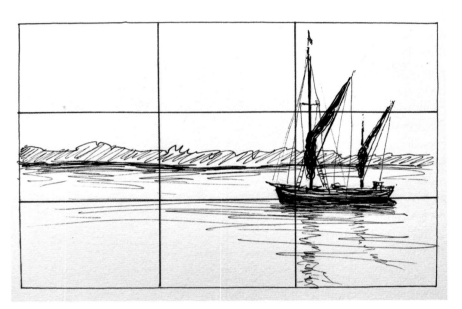

Note how the sailing barge is placed about one third in from the right, creating a strong focal point in this simple composition.

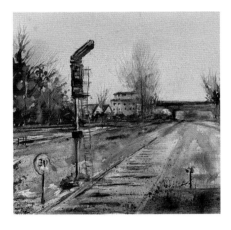

Following the rule of thirds, this painting positions the signal post about a third of the way into the composition, on the left. It is painted with more detail than the rest of the painting and, surrounded by a muted colour palette, the colour of the signal light draws attention to it. The signal also leads the viewer's eye to the railway track, which follows the rules of one-point linear perspective as it disappears into the distance.

Thumbnail sketches

Planning the composition before committing to painting helps to ensure that everything will fit on your paper and work together as a whole. It can be helpful to try out a few different variations of the same scene on scrap paper or in a sketchbook in order to discover which arrangement you will find the most visually pleasing. These little sketches are known as 'thumbnail sketches' and can help you to work out potential problems before you begin.

Use thumbnail sketches to roughly plan out different versions of the same scene to discover which you prefer. Try to keep them very quick and rough: all they need to do is help you decide which ideas will work the best for you.

Perspective

You can use two types of perspective in your paintings to achieve a convincing illusion of depth and distance: linear perspective and aerial perspective.

Linear perspective

There are many facets to this topic, depending on how complex you want your paintings to be. For our purposes, one-point perspective is a great starting point. You can think of this in terms of a 'vanishing point' on the horizon at eye level. So, things will become smaller, and appear closer together, the further they recede into the distance until they reach the vanishing point on the horizon.

If you can imagine converging lines radiating out from the vanishing point, these will enable you to correctly position objects such as trees, telegraph poles, buildings and fences as they recede into the distance. These converging lines will also help you to get the perspective right for the ground plane and the sky.

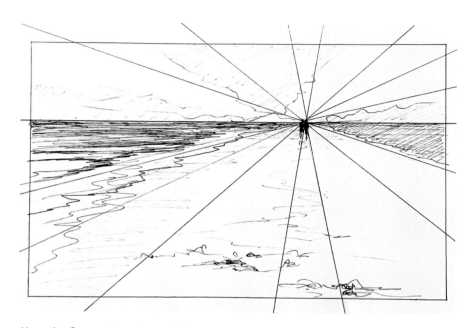

Here the figures' heads mark the position of the vanishing point on the horizon. Note how the water's edge, beach and sky are all following the converging lines, thus keeping everything in proportion and perspective.

Aerial perspective

The principle behind aerial perspective is that things appear paler and less distinct the further away they are; whereas in the foreground, things are crisper and more detailed. You can use this knowledge to achieve a sense of depth and distance in your paintings by paying attention to the values of paint you use as well as the amount of detail you include. Generally, cool colours like blues and violets recede and appear more distant and are used for faraway objects in a landscape. By contrast, warmer colours tend to come forward and are more regularly used to paint things in the foreground.

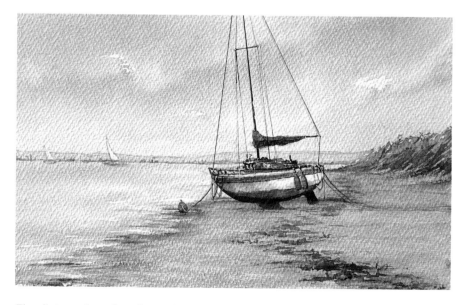

The distant shore is paler and less distinct than in the middle ground and foreground, adding depth and distance through use of aerial perspective.

Preliminary Drawings

Drawing and sketching are important skills for a watercolour landscape painter. Anyone can learn to do these – it just takes a bit of practice to build confidence. The best way to begin is to take a close look at the world around you and simplify what you see to help you translate it onto the paper. Once you have your sketch, you can begin to apply washes of paint.

All the projects in this book will begin in one of two ways. The pure watercolours will need a simple preliminary sketch using a B or HB pencil. However, the line and wash paintings will require a more detailed linework sketch, following the four-stage process I devised to complete the linework and shading.

Preliminary pencil sketch

Pure watercolour paintings usually only need a quick pencil sketch, with a few marks to indicate the horizon and some simply sketched key elements to act as a guide for your painting. The sketch will be covered over as you paint, unlike the sketch in the line and wash technique that informs the painting's structure.

Lightly sketch the outline with a B or HB pencil. Try not to press too hard: otherwise, you will indent the paper. Use an eraser to correct any misplaced lines. Try to keep your pencil lines loose and sketchy, as this will result in a more expressive final painting. Too much detail at this stage risks the final painting becoming a little fussy.

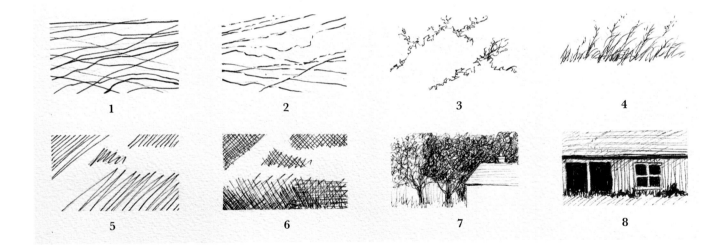

Tip

You can draw straight lines for the horizon and for objects such as buildings either freehand or with a ruler. Drawing them freehand will keep everything looking fresh and loose, but you can use a ruler if you prefer. As you progress through the projects in this book, you will discover which method works best for you.

The various linework and shading techniques for making pencil sketches and inked outlines for the projects in this book include:

1 Lines
2 Broken, or hit and miss, lines
3 Scribble lines
4 Grass and plant lines

5 Hatching
6 Cross-hatching
7 Scribble shading
8 Blocked-in dark shading

Four-stage detailed linework process

You will need an HB or B pencil, an eraser, a ruler, and 0.3mm, 0.5mm and 0.7mm black waterproof fineliner pens. You will also need a 0.7mm white acrylic ink pen or white gouache for highlights, which can really elevate your painting.

Once you become familiar with the technique, you may wish to experiment with a dip pen and waterproof ink, which can give very different results.

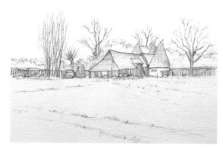

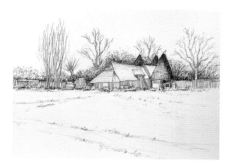

STAGE ONE

Carefully sketch your scene using any of the pencil sketch techniques on the facing page that are appropriate for the project you are working on. Use a ruler if needed and erase any mistakes as you go. Try to make sure your sketch is as accurate as possible before adding ink.

STAGE TWO

Draw over the pencil outline with a 0.3mm or 0.5mm black waterproof fineliner pen. Try to vary the line width and get used to allowing the pen to skim lightly over the texture of the paper in some places. Use less pressure for finer lines. Don't worry if some of the lines look imperfect – this gives an expressive quality that adds character to your painting. As a general rule, leave horizon lines as pencil marks, rather than inking them in, as skies tend to look better with a soft transition between land and sky.

STAGE THREE

Using the 0.3mm or 0.5mm fineliner, add middle and darker value shadows and shading using hatching, cross-hatching and scribble shading (see opposite). Natural elements such as trees and grass can be shaded using combinations of scribble shading and a little hatching. Artificial features such as buildings work better if shaded in a more geometric fashion, using hatching and/or cross-hatching. Fine shadows, such as beneath a building's eaves, can be emphasized by using the 0.7mm pen to produce a heavier line.

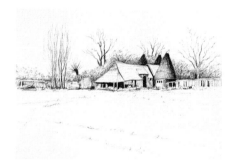

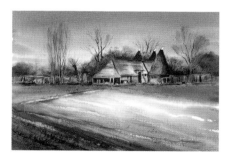

STAGE FOUR

Using the 0.7mm fineliner, carefully block out the darkest value areas where the main point of interest will be. In this example, it is inside and around the barn. This adds depth and dimension and draws attention to the focal point. A few more places may also benefit from blocked-in darks, but try not to overdo it, which may detract from your main point of interest.

When your linework is finished, leave it for a few minutes to dry, then erase any visible pencil marks.

ADDING THE WASH

Once the linework and shading has been completed, the painting aspect of a line and wash is fairly straightforward. A few washes and details, using the techniques outlined in 'Basic Watercolour Techniques' (see pages 22–25) will bring the painting together.

Tip

Sometimes you may need to go over the linework at the end of the painting and add a bit more shading if the washes have dulled it in places. Adding a few white highlights with a white acrylic fineliner or white gouache paint can also be very effective.

Basic Watercolour Techniques

Watercolour paintings are built up using a variety of different painting techniques, which can be combined in different ways to create almost limitless possibilities in your paintings. The two main techniques you will be using in this book will be wet-in-wet and wet-on-dry.

Wet-in-wet technique

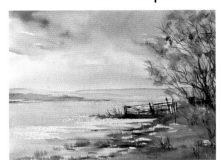

This technique involves painting onto a wet surface so that the marks soften, blend and diffuse on the page. This technique is used to create a sky wash: by wetting the area with clean water first, then adding washes of colour onto the wet paper, you can create soft transitions of colour and cloud. This method can also be used for applying different colours for details, so that they run and blend together on the page.

Wet-on-dry technique

As the name of this technique suggests, painting wet-on-dry is the method of painting straight onto the dry paper without pre-wetting it, or painting onto a wash that has already fully dried. The effects created using this method are more controlled than wet-in-wet, as the paint stays where you put it. This makes it ideal for painting harder edges and details, as well as for building up glazes and increasing value on earlier washes.

Tip

Once the paper no longer has a wet 'sheen' after it has been painted, it is time to step away and leave the paper to dry. Runbacks are more likely to occur if you try to paint into the wash at this stage.

The wet-on-dry technique is used for most types of glazing (see opposite), where transparent washes are painted over a dry paint layer to increase the tone or change the hue.

HOW TO AVOID RUNBACKS

When using the wet-in-wet technique, you are at risk of runbacks or blooms, sometimes known as 'cauliflower marks'. As soon as wet paint goes on the paper, it will begin to dry. Very wet paint added to a drying wash will run the risk of creating a runback or 'cauliflower.' This occurs when the wetter paint interrupts the smooth drying of the paint that has already been laid down, pushing the pigment out of place and creating a bloom-like mark. While some artists use these

blooms to their advantage, these marks can spoil the look of a fresh, clean wash, so they are best avoided.

You can manage this by ensuring that any paint added to a drying wash is less wet than the colour that has just been laid down. Try to get into the habit of keeping a sponge or absorbent kitchen paper nearby and dabbing your brush onto it regularly – both after rinsing, and once you've loaded it with paint. This will easily remove any excess water and give you a drier blend of colour to paint with.

Washes

Washes of colour can be applied either wet-in-wet or wet-on-dry. They can be flat, with one even colour throughout; or they can be graduated, softly changing in value from light to dark or by using different colours in the same wash.

Tip

If you find that the paint is running down the page too much, simply decrease the angle of your board, or rotate it approximately 90 degrees to halt the flow, then turn it back to its original position.

FLAT WASH

For a flat wash, it is best to set the board at a low angle so that gravity helps create an even, flat wash. Mix enough paint to cover the area required and load a wash brush (a mottler or mop brush) with paint. Start at the top of the paper and paint a horizontal brushstroke or two from one side to the other. A bead of wet paint will form across the bottom edge of your brushstroke. Load the brush with paint again, and paint into this bead using another horizontal brushstroke, keeping the colour even. Continue down the page until you have created a smooth wash. Use a clean, damp brush to remove the bead from the bottom edge of the paper, wipe the tape to remove excess water or paint, and lay the board flat to dry.

GRADUATED WASH

To paint a graduated wash using just one colour, follow the instructions for the flat wash (see left). However, instead of reloading the brush with more paint after the first few strokes, allow the paint to gradually run out as you paint, dipping the brush into a little more water if needed. The paint will become paler as the wash progresses down the page. To transition from a pale colour back to a dark one, simply reload the brush with paint and continue. In this same manner, different paints can be added to a graduated wash to produce soft blends of colour. For this, it's best to pre-mix all the colours you need for the wash and have them ready before you begin, so that you can transition easily from painting one colour to the next.

Glazing

Watercolour is a transparent medium, so you can 'glaze' dry washes with a layer of the same colour to deepen or strengthen the tonal value; you can also glaze it with a different colour to tint it. Glazing can only be done on a painting that is already bone dry. Mix a light value of your chosen glaze colour and paint, lightly and swiftly, over the area you wish to glaze. Use as few brushstrokes as possible so as not to disturb the dry paint underneath.

Tip

If you are glazing a large area, gently wet it again with a soft wash brush first.

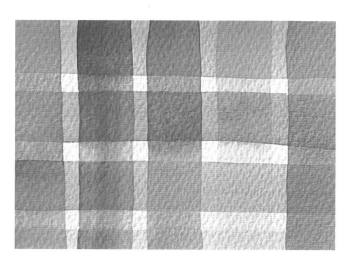

Lifting out paint

It is possible to 'lift out' areas of wet paint to lighten or remove it. Use a clean, damp brush with all excess moisture removed to lift colour from a wet wash.

You can also lift paint by using absorbent kitchen paper: crumple it and dab gently. This is a great way to create pale clouds in a wet sky wash.

To lift paint from a wash that has completely dried, first carefully wet the area to be lifted with a clean, damp brush. Wait for a few seconds for the water to soak in, then dab it with a piece of clean kitchen paper.

The three lifting techniques:
1 Lifting wet paint with a damp brush
2 Lifting paint with kitchen paper
3 Lifting dry paint

Preserving white paper

In watercolour painting, white elements are often represented by the unpainted paper. You can paint around elements of your composition in order to preserve the white; however, sometimes this can be difficult, so there are several alternative methods you can use to help with this.

Tip
Never use your best brushes to apply masking fluid – use an old, small brush to apply it, as without the proper care, the fluid can easily set into the brush and damage it. To avoid this, rub the brush bristles with water and a little soap before dipping into the masking fluid; this will protect the bristles and allow you to wash the masking fluid cleanly from the brush after use. You can purchase specialist brush soap for this purpose or use hand soap.

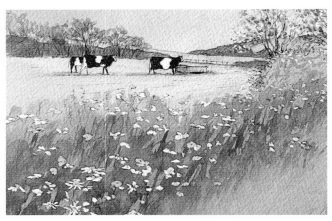

MASKING FLUID

One method for protecting white areas is to use masking fluid. This is a gum-like mixture that is painted directly onto the area you wish to protect; you can then freely paint over once it has dried. Once the painted area is fully dry, you can remove the masking fluid by rubbing it gently with a clean, dry finger.

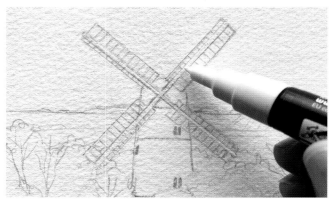

WHITE ACRYLIC FINELINER PENS

White acrylic fineliner pens can also be used as a subtle resist. The sails in the 'Windmill in the Snow' project (see pages 60–65) were drawn in first using acrylic fineliner pen. This allowed them to be seen more clearly through subsequent washes of paint, before being detailed at the end.

Brushwork

The best way to discover what your brushes can do for you is to experiment freely on scrap paper. See what happens if you paint with different parts of the brush: the tip, edge, belly, etc. See just how fine your marks can go when you change the pressure applied when painting, and just how thick or wide a mark you can make using a single brushstroke. This type of exploration is a lot of fun, and will teach you far more than I am able to here!

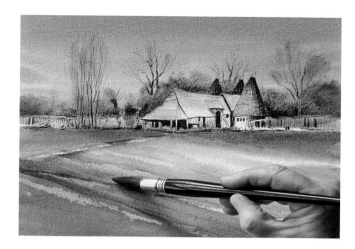

Holding a brush

Try holding your brushes roughly halfway down the handle, instead of right up the end of the ferrule like a pen. This can take a bit of getting used to, but it will help you to keep your brushstrokes fresher and looser, creating sweeping, expressive marks painted using your whole arm rather than just your hand and wrist.

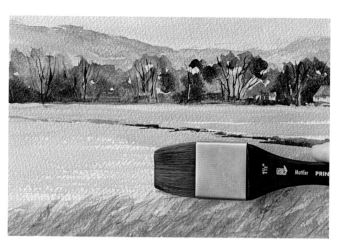

Dry brush technique

Create a 'drier' paint mix using less water than you would for a fluid wash. Dab your brush onto absorbent kitchen paper to remove excess moisture. Hold your brush at a shallow angle to the paper. The paint will transfer to the raised texture, leaving the dimples unpainted. This can produce a 'sparkling' effect and is often used for painting light reflected on water.

Calligraphic brushwork

Inspired by the art of calligraphy, calligraphic brushwork is an expressive way of creating loose patterns and textures for landscape elements such as grasses and foliage. I like to use the tips of the round brushes or rigger for this, dancing the brush around on the page, changing the pressure on the tip of the brush to vary the width and direction of the brushstroke. You can add different colours to wet blend on the paper, to add a variety of colour and tone. The example above shows how different greens can be painted with calligraphic brushstrokes to build up fresh, varied tree foliage, leaving plenty of gaps in the pattern to allow the sky to peek through.

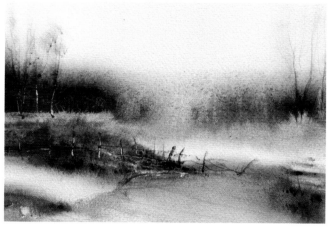

Palette knife marks

A palette knife can be used to scrape marks through damp paint, revealing the paper or a dry wash beneath. This can create lovely highlights and textures, and it gives interesting hard edges against softly diffused wet-in-wet washes.

Mixing and rinsing brushes

Some artists like to use a dedicated small to mid-sized mixing brush to keep the painting brushes cleaner. Alternatively, you can of course mix colour using the brush you are about to use.

When changing colours, thoroughly rinse your brush and dab it on kitchen paper or a sponge to remove excess water.

Hedgerow in Springtime

Fresh and bright, speckled with Queen Anne's lace, ox-eye daisies and yellow poppies, overgrown hedgerows and field boundaries can be beautiful and inspiring places, where the blackthorn blossoms bloom brightly among the trees.

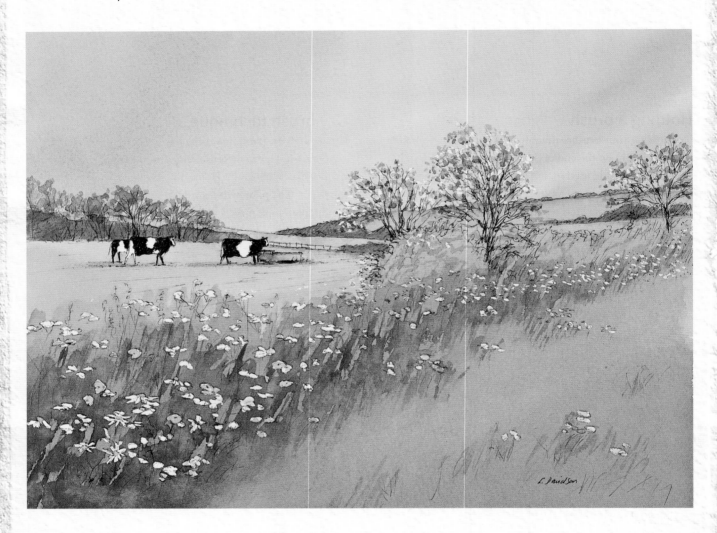

COLOURS NEEDED

Cerulean blue	Winsor blue	Cadmium yellow hue	Burnt sienna	Payne's grey

Any basic scene such as this can be simplified and adapted slightly to create a wonderful painting. I kept the main composition the same, but I added two more cows and changed them from brown to black and white, as I felt that would work better against the fresh spring grasses and pretty white flowers in the hedgerow. A few larger, blossom-covered trees add interest to the middle ground. Limiting the colours of the flowers to only white and yellow helps add to the springtime feel of this piece.

Sketch the scene lightly in pencil, then draw using waterproof black fineliners for the outlines and shading, following the four-stage detailed linework process (see page 21).

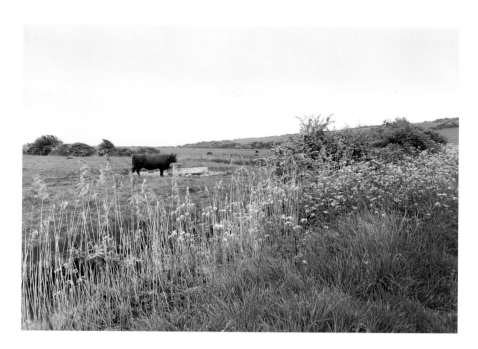

Masking

In order to preserve the white paper, use a small brush – an old one will be ideal – to apply masking fluid to the flowers and white parts of the cows (see page 24). The flowers should be larger and more detailed in the foreground, but make them smaller and less detailed as they go further back until they become little specks in the distance.

Allow the masking fluid to dry completely. It takes a while to dry, but if you paint over damp masking fluid, it will peel away. Once the fluid is dry, tape the paper to the board with masking tape and set it an angle of around 20 degrees.

YOU WILL NEED

- 140lb (300gsm) cold pressed (NOT) watercolour paper
- HB or B pencil, ruler and eraser
- 0.3mm, 0.5mm and 0.7mm waterproof black fineliner pens

- Masking fluid and an old, small brush
- Painting board and masking tape
- Sponge and kitchen paper

- Palette with several large mixing wells
- No. 14 mop brush
- No. 4 and 14 round brushes
- No. 2 rigger brush

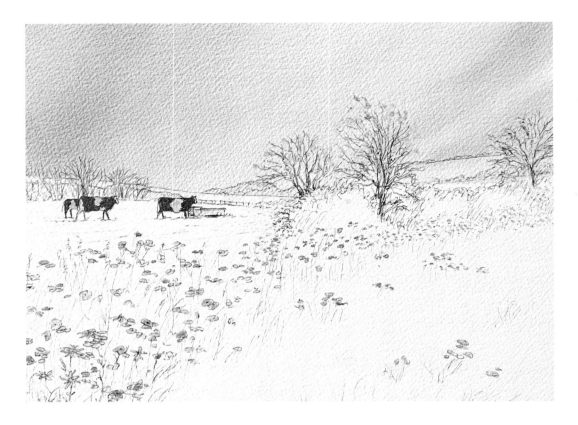

Using diagonal brushstrokes from the hilltop towards the top of the page will help to make the sky a little more dynamic.

STAGE 1

The sky is painted using the wet-in-wet technique (see page 22). Mix up a well of cerulean blue, then wet the sky with clean water using the mop brush. Allow the water to soak in for around 30 seconds. Beginning from the left, paint the sky using shallow diagonal brushstrokes. Keeping the blue darker on the left, allow it to become paler towards the right. Add more cerulean blue to deepen the colour in the left corner if necessary, bringing this colour over the distant hills on the right.

If a bead of paint forms across the top of the hill, use a clean damp brush (any brush will do) to carefully remove it. Wipe the masking tape clean: this ensures that any pools of water remaining on the tape don't run back into the sky as it dries, causing unsightly marks. Leave to dry.

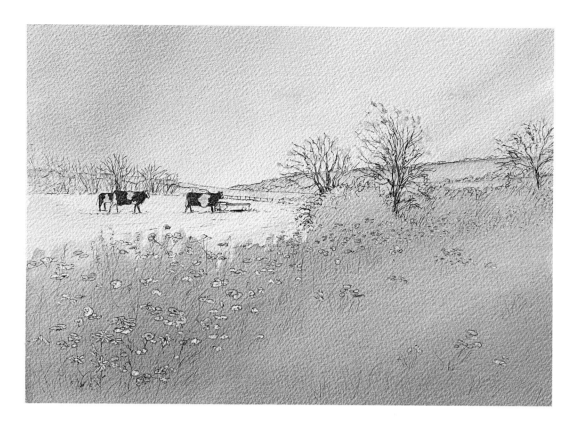

STAGE 2

Mix a light value green from Winsor blue, cadmium yellow and a dab of burnt sienna to paint the distant hills and pasture, and also make a stronger, mid-value mix of the same colours, using more paint and less water, to make a deeper, earthy green for the hedgerow and foreground.

Paint the lighter colour across the distant hill and the cow pasture on the left, using the mop brush. Then, change to the darker mix and sweep this across the rest of the page. Paint straight over the flowers, as the masking fluid will protect them.

Add more burnt sienna and a touch more Winsor blue to the mid-value green mix to darken it, and paint this over the flowers. Dip into a little cerulean blue and paint it over the grass in the bottom right corner, just to get a hint of blue tone into the grass colour. Leave to dry.

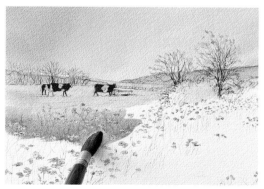

Painting a graduated wash (see page 23) starting with a light value green and then changing to the mid-value mix will help the pasture and cows stand out.

Tip

Adding more of the earthy green around the flowers will begin to establish shadows and depth in the hedgerow.

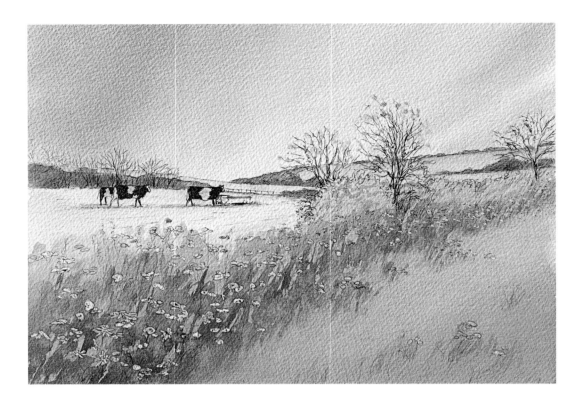

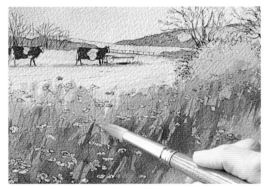

Angle the brushstrokes towards the top right to add to the dynamic of this scene. It will also help to suggest the stalks and grasses in the hedgerow.

STAGE 3

Use the same earthy green mix from Stage 2 to paint the distant trees.

Mix a darker value green from Winsor blue, cadmium yellow and burnt sienna, then using the no. 14 round brush, add deeper shadows over the flowers, painting wet on the dry wash for harder edges. Swap to the rigger brush as the hedge recedes into the distance, painting smaller flicks of shadow. If the marks become too harsh or dark in places, dab gently with a piece of absorbent kitchen paper. Leave to dry completely.

Tip
Flick the darker green downwards with the rigger to suggest blades of grass.

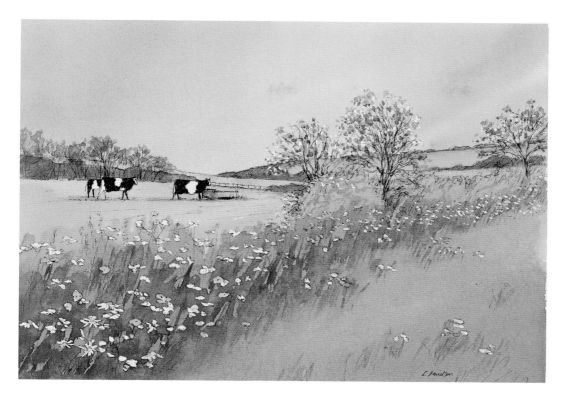

STAGE 4

Remove the masking fluid by rubbing it off carefully with a clean fingertip. Mix two mid-value greens using Winsor blue, cadmium yellow hue and burnt sienna: one brighter, with more cadmium yellow; one darker and earthier using more burnt sienna.

With the no. 4 round brush, paint over the distant trees on the left using the darker mix, then carefully paint around the blossom on the other trees, alternating between the two greens. Leave the spots of blossom white. Add a few light dabs of cadmium yellow hue into the lighter green for added brightness. Mix a little light value Payne's grey and use it to paint the water trough.

Finally, paint the poppies and daisy centres with a dark value cadmium yellow hue. Leave most of the flowers as white unpainted paper, to show off the Queen Anne's lace and ox-eye daisies in all their natural glory. Leave to dry.

Use the no. 4 round brush to add delicate dabs of colour.

Tip

White and yellow are the perfect colours for spring flowers. To create a natural-looking balance of colour, consider how the yellow flowers are spaced between the white flowers when you are painting them.

FOCUS ON
Painting Skies

Arguably the most important element in a landscape painting is the sky. It can act as the dominant part of the painting, arcing over everything, or as a quiet backdrop to an interesting scene. The sky sets the tone for the entire painting in terms of atmosphere, weather and time of day. The landscape below is influenced by the sky.

Skies using flat and graduated washes

It is possible to create many types of atmospheric skies by using the basic techniques for painting flat and graduated washes (see page 23).

A flat wash of blue using cerulean, cobalt or ultramarine can provide a simple, warm summer sky, whereas a flat wash of Payne's grey will suggest a cold, grey winter sky. You can give a single-colour sky more nuance by graduating the wash, so that it becomes darker across the top and paler towards the horizon or vice versa.

Adding different colours to graduated washes will offer almost unlimited scope for variations in skies.

Painting around clouds

In this example, washes of cobalt blue and the palest raw sienna create a deep blue sky with dramatic clouds. Brush clean water onto the paper where the sky will have colour, leaving cloud areas dry. Next, using a large mop brush, apply washes of colour to the paper in varying strengths, pushing the brush around the sky and around the clouds' edges to soften the transitions between wet and dry paper. Light value raw sienna will work well as a starting point to tint the white paper in places, followed by blue; then add a touch of light red or burnt sienna to create cloud shadows.

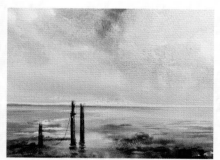

Changing the colour palette for your skies to something like Payne's grey, yellow ochre and burnt umber can create atmospheric clouds and stormy skies. Alternatively, desaturating your blue tones with indigo, Payne's grey or something similar, then adding reds, oranges and violets can give pleasing sunset and sunrise effects.

Lifting out clouds

While the paint is still wet, you can lift out clouds from a sky wash by dabbing with absorbent kitchen paper to remove the paint and create cloud shapes. Go gently, as it is easy to remove too much paint, which can sometimes look a little stark. Remember to turn the paper over to a clean part between dabs, otherwise you may transfer the lifted paint back onto the painting. You can also use a damp sponge for this technique, which will yield slightly different effects.

Many different types of clouds can be created this way. Experiment with different colour combinations and see what happens!

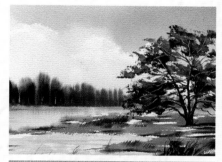

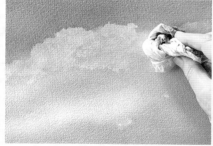

Tip
When using the lifting out method, try to use non-staining colours. Some pigments such as phthalo blue and Prussian blue will leave a light stain.

Should the land or sky dominate?

Let's consider skies as an element of the composition. If you want the sky to be the dominant feature in a painting, plan a sky that draws the eye towards it more than the landscape below it. In this case, the sky may take up at least two thirds of the paper, and the land should be fairly simple by comparison.

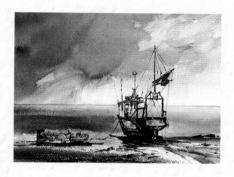

However, if the landscape itself is the focus, then a simpler sky helps to keep the attention on the land, but it can still help create atmosphere.

Tip
Try to avoid having a lot going on in both the sky and land, as this can lead to an image that looks too busy or confusing.

Rolling Hills and Summer Sky

The beautiful summer sky reflected in the still water of this pool is the focus in this painting, along with simple yet attractive features: an old gate and a broken fence disappearing into the water.

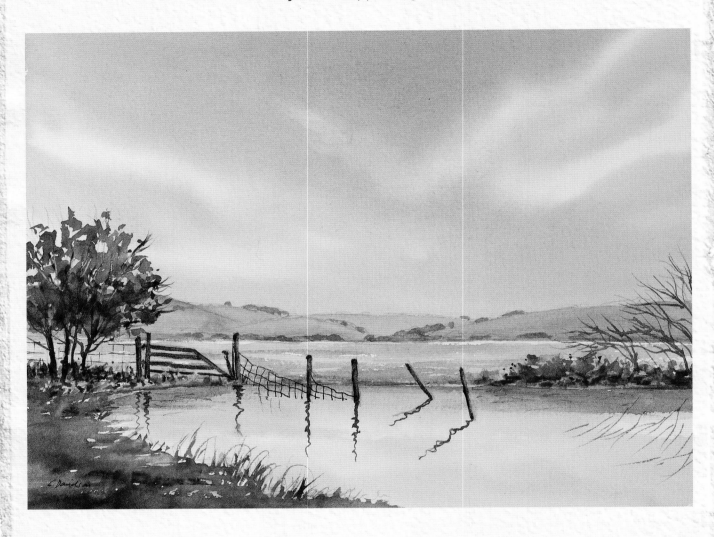

COLOURS NEEDED

Cerulean blue	Ultramarine blue	Raw sienna	Burnt sienna	Burnt umber	Payne's grey	Cadmium yellow hue

It is a good idea to try to simplify photos like this before painting. I do so by trying out a sketch or two where I only include the main elements, leaving out any details that might be a bit distracting in a painting. Here is a basic pencil sketch I did to simplify the scene, including the distant hills and trees, the middle-ground field, the foreground tree, bushes, pond, and a simplified version of the gate, fence and posts. Everything else has been left out to keep the painting as simple as possible.

Tonal sketches

It can also be helpful to do a small tonal value sketch based on the simplified pencil sketch, but this time provide a location for the three main tonal values that will help to create shape and form. The lightest lights are represented by the white paper, the mid-values by shaded areas and the darks are heavily shaded or blocked in. These sketches can be referred to as a kind of road map for the preliminary sketch and painting.

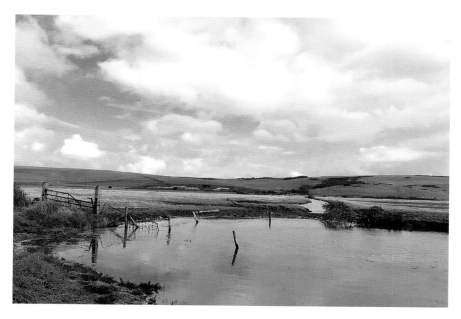

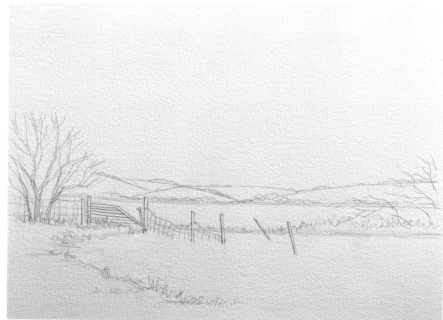

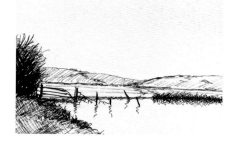

YOU WILL NEED

- 140lb (300gsm) cold pressed (NOT) watercolour paper
- Sketchbook or sketching paper
- HB or B pencil, ruler and eraser
- 0.3mm, 0.5mm and 0.7mm waterproof black fineliner pens

- Painting board and masking tape
- Sponge and kitchen paper
- Palette with several large mixing wells
- Palette knife

- No. 14 mop brush
- Nos. 4 and 14 round brushes
- No. 2 rigger brush
- ¾in (19mm) flat brush

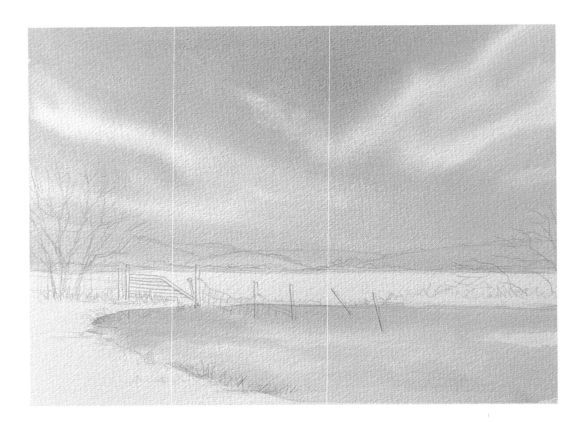

Graduate the wash a little (see page 23) so it becomes paler over the distant hills, stopping at the horizon.

STAGE 1

Paint in the sky using the wet-in-wet technique (see page 22). Set your board at a low angle of around 20 degrees. Mix up a large well of cerulean blue and ultramarine blue to make a mid-value sky blue colour; make sure you mix enough for the whole sky. In a separate well, mix a small amount of light value raw sienna.

Using clean water and the no. 14 mop brush, wet the sky coming down over the distant hills and stopping at the horizon line, then wet the foreground pond. Let the water soak into the paper for 30 seconds or so, then remove any excess water with a clean damp sponge. The surface of these areas should be evenly damp.

Paint a little raw sienna across the middle of the sky and across the pond. Next, paint the sky with the blue mix, starting in the middle and sweeping the brush out towards the top and sides, leaving a few streaks of unpainted paper and raw sienna for clouds. Repeat across the pond with the flat brush.

Tip
Use the tips of the flat brush to paint around the edge of the pond, allowing the blue and raw sienna to blend.

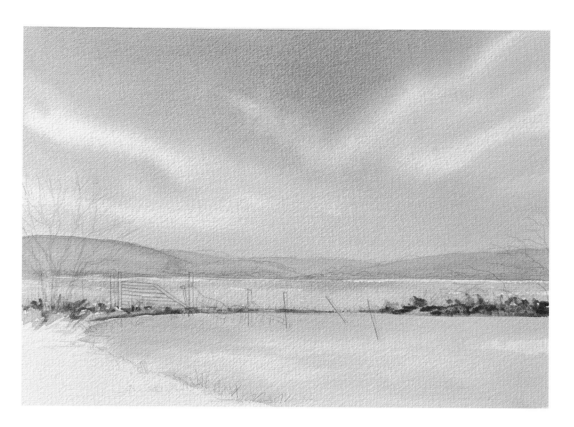

STAGE 2

Mix up a light value green for the distant hills from cerulean blue and ultramarine blue along with cadmium yellow hue and a touch of raw sienna. Paint it across the hills and down to the horizon with the no. 14 round brush.

Mix some mid-value raw sienna and paint the middle-ground field, leaving a slim gap of white paper between the horizon line and the field if you can: this will add a subtle glow of light across the distant field. While the paint is still wet, add more raw sienna to your mix, then paint a few darker brushstrokes into the field. Use horizontal brushstrokes to paint fields and plains; this will help keep the land looking flat.

Add some burnt umber to this mix and use this darker colour to begin the grass below the tree and gate. Add some of the same mix along the bank of the pond and into the low bushes on the right. Add a little Payne's grey and keep dabbing into the low bushes, placing a further few dabs below the tree. Leave to dry.

Adding tone with the no. 14 round brush will help to define the bank.

Tip
Try to keep your brushwork delicate but sketchy for a loose, natural appearance.

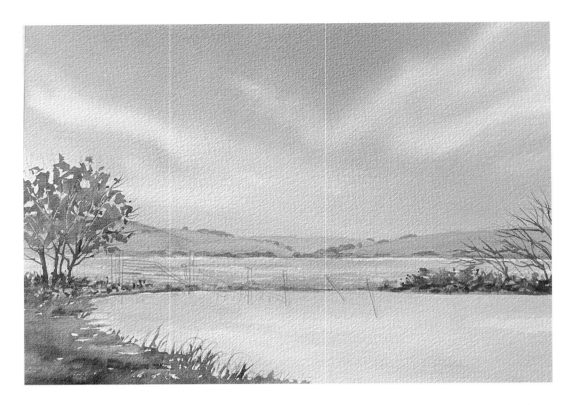

Paint these branches leaning into the picture to lead the eye into the painting.

Tip
Paint the grasses that grow around the edge of the pond so that they are a little taller.

STAGE 3

Mix up a similar light value green to the distant hills mix from Stage 2, but use a touch of burnt sienna as well as raw sienna to darken it. Using the no. 4 round brush, paint the small trees on the hills and the horizon line, following the pencil outline.

Mix a mid-value green from ultramarine blue, cadmium yellow hue and raw sienna. With the no. 14 round brush, paint the tree canopy using calligraphic brushstrokes (see page 25), leaving a few gaps for the sky to show through.

Use burnt umber to darken a few areas of the tree, and dab gently with a piece of kitchen paper to lift a little paint in a few spots. Repeat with the low bushes on the right. While the tree canopy is still wet, scrape a few lighter branches through the paint with the palette knife (see page 25).

Make more of the same green mix and paint the foreground with horizontal brushstrokes, using a few calligraphic brushstrokes for texture. Touch in a little burnt umber and allow to blend, and paint a few darker grasses under the tree. Add grasses to the pond edge with the no. 2 rigger brush.

Mix a dark value brown for the tree trunks and branches from ultramarine blue, burnt sienna and Payne's grey, then paint these with the rigger brush. Repeat this process for the branches of the tree on the right. Leave to dry.

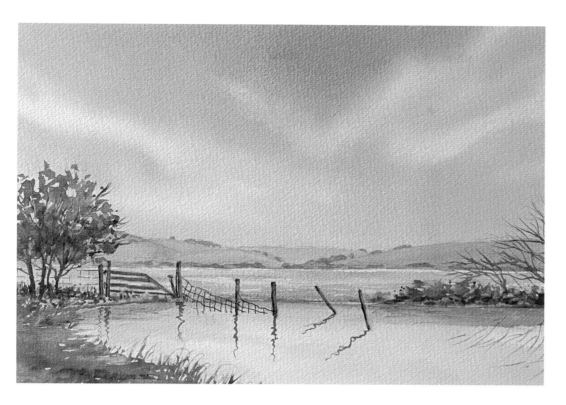

STAGE 4

Mix up a light value grey using ultramarine blue, burnt sienna and raw sienna, then paint shadowy reflections along the waterline and the bank. Next, paint a heavier shadow under the gate using the no. 14 round brush.

Mix a dark value brown from burnt sienna, ultramarine blue and burnt umber, and using the no. 4 round brush, paint the fence posts and gate, leaving the fence wire unpainted. Add a few little dark brushstrokes under the tree for shadow.

Make up a light value glaze of raw sienna and glaze the foreground (see page 23), which will help to brighten it.

Mix a dark value green from ultramarine blue, raw sienna, a little cadmium yellow hue and burnt sienna to add some shadows to the tree canopy.

Draw the fencing wire with the 0.3mm fineliner pen.

Finally, using the rigger brush and the dark mixture for the fence posts and gate, paint a wiggly line below each fence post for the reflections in the pond. Add a few faint lines below the gate, and a few below the bushes. Leave to fully dry.

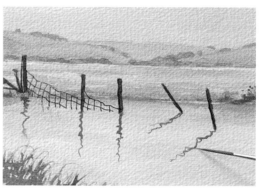

Try to mirror the direction of each pole or gatepost, darker below the post and lighter at the end.

Tip

Use the tip of the round brush to paint the finer shadows, then use the belly of the brush for the wider strokes.

Shaded Summer Path

A cool, shady path is a wonderful place to pause and look around during a summer walk, taking time to breathe in the sweet fresh air, and to notice the bright poppies and wild buttercups springing up beside you.

COLOURS NEEDED

| Ultramarine blue | Cerulean blue | Lemon yellow | Burnt sienna | Burnt umber | Cadmium yellow hue | Cadmium red hue |

Sometimes, the simplest of compositions can be the most rewarding in terms of atmosphere. This shady pathway, replete with wildflowers, invites the viewer to take a walk into the sunlit meadow beyond.

Start by making a linework outline and shading it using the techniques in the four-stage detailed linework process (see page 21). Notice that most of the flowers are drawn as little more than tiny circles and ovals, apart from in the foreground where a few daisies, poppies and buttercups are given slightly more definition. As the blooms recede into the mid-ground, this lack of detail and their gradually smaller size helps enhance the illusion of distance.

Masking

Paint masking fluid over the little flowers to protect the white paper (see page 24). This will ensure the red and yellow flowers remain bright and cheerful, as well as help them to stand out beautifully against the green grass and hedges. Watercolour is a transparent medium, so if you painted the flowers over the grass, the green paint would show through and make the flowers look dull.

When you are ready to begin painting, set your board to a low angle of around 20 degrees.

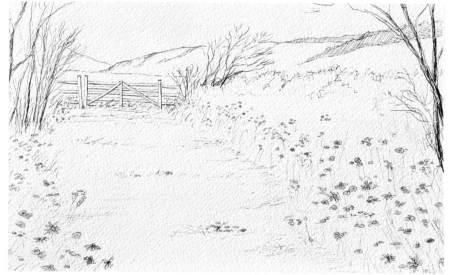

YOU WILL NEED

- 140lb (300gsm) cold pressed (NOT) watercolour paper
- HB or B pencil, ruler and eraser
- 0.3mm, 0.5mm and 0.7mm waterproof black fineliner pens

- Masking fluid and an old, small brush
- Painting board and masking tape
- Sponge and kitchen paper

- Palette with several large mixing wells
- No. 14 mop brush
- No. 4 round brush

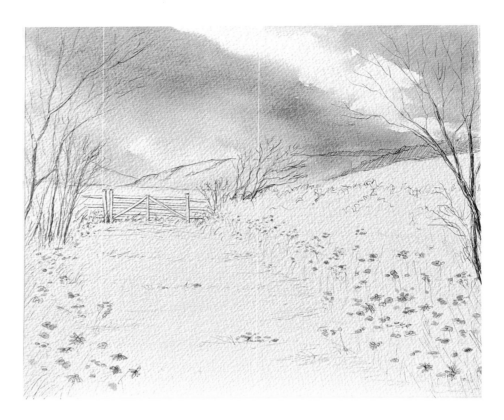

Bring some of the sky colour over the distant hills to help with the illusion of aerial perspective, as cool colours recede.

STAGE 1

Paint in the sky using the wet-in-wet technique (see page 22). Mix up a large well of sky colour, using ultramarine blue with a dab of cerulean blue. Wet most of the sky, leaving a few patches of dry paper for loose clouds, then wet the distant hills. Allow the water to settle into the paper for around 30 seconds, before removing any excess with a clean, damp sponge. Paint the sky using the no. 14 mop brush, working around the cloud shapes to maintain some of the white paper. Try to keep the wash darker in the top left and lighter across the bottom.

Use a piece of absorbent kitchen paper to lift out or enhance the clouds if needed (see page 33), and dab out any sky colour that seeps into the middle-ground field. Leave the sky to dry completely before moving on.

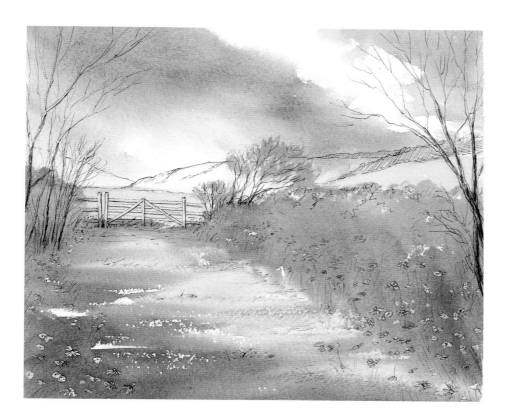

STAGE 2

Mix three slightly different greens: a bright mid-value green from lemon yellow and a touch of ultramarine blue; a bluer mid-value green from lemon yellow with a bit more ultramarine blue and a touch of burnt sienna; and a more earthy green in a darker value from the same colours, but using more ultramarine blue and burnt sienna.

Using the mop brush, first paint the field behind the gate and middle-ground hill with the brighter green. Next, swap to the bluer green and paint the path; finally, paint the hedges in by using the darker, more earthy green, painting across the pathway with horizontal brushstrokes.

Add a touch more burnt sienna and ultramarine blue to the dark mix, then add more shadows to both the base of the hedge and the lower left corner of the path.

Paint the small tree in the middle with the bluer green. Leave to dry.

Keep the path lighter towards the right side with the bluer green, using some dry brushstrokes (see page 25) if possible.

Tip
Paint the left side of the path and right foreground hedge with the darkest green mixture and allow the colours to blend wet-in-wet to create shadow effects.

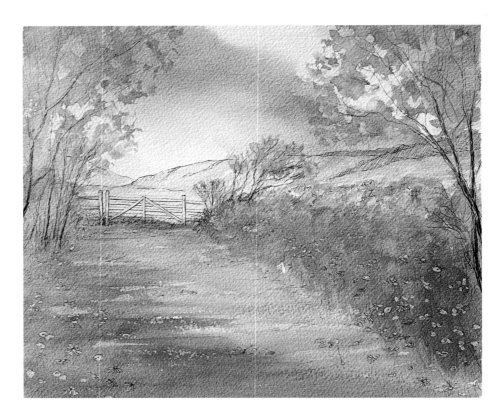

STAGE 3

Mix up a light value glaze of cerulean blue, lemon yellow and a dab of ultramarine blue, and apply this to glaze (see page 23) lightly over the distant hills. Continue the glaze over the middle-ground field and hill, leaving the brighter underpainting showing through in patches. Blend a little more ultramarine blue into the mixture, then glaze the path and hedges.

Mix up a mid to dark value mix of ultramarine blue and lemon yellow, and using the no. 4 round brush, paint the large trees with calligraphic brushstrokes (see page 25). Make sure you leave some small gaps for the sky to show through the foliage. Add dabs of darker green while still wet for a little tonal variety. Leave to dry completely.

Add little dots of green around the edges of the tree canopies with the tip of the no. 4 round brush.

Tip
Lift out some paint with absorbent kitchen paper to lighten the tops of the hedge and to blend if necessary.

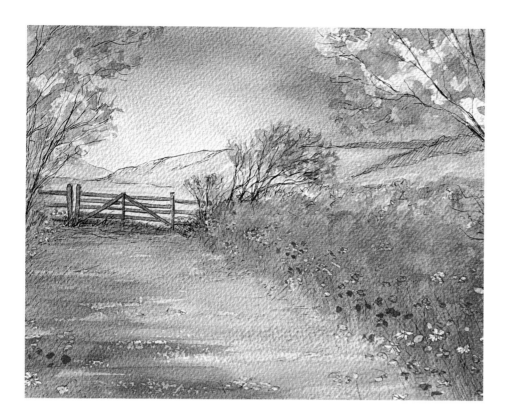

STAGE 4

When you are sure the painting is bone dry, gently rub the masking fluid away from the flowers with your fingertip. Use the 0.5mm or 0.7mm fineliner to strengthen and darken the tree trunks and branches if necessary. Then, in separate wells, mix some dark value cadmium red hue and some cadmium yellow hue for the flowers. Paint the poppies red, the buttercups and daisy middles yellow, but leave the daisy petals white. These summer colours will really make the greens pop.

Paint the fence with burnt umber using the no. 4 round brush. Leave to dry.

Keep the fence a little darker on the left, which is where it sits in the shade.

Tip
Cadmium yellow hue is a warmer colour than lemon yellow, which will make the flowers stand out more.

Sailing Boats and Golden Sands

When using a photograph as inspiration for a painting, don't be afraid to change things up a bit. Rather than copying exactly from the photo, use your artistic licence to create a unique piece of art.

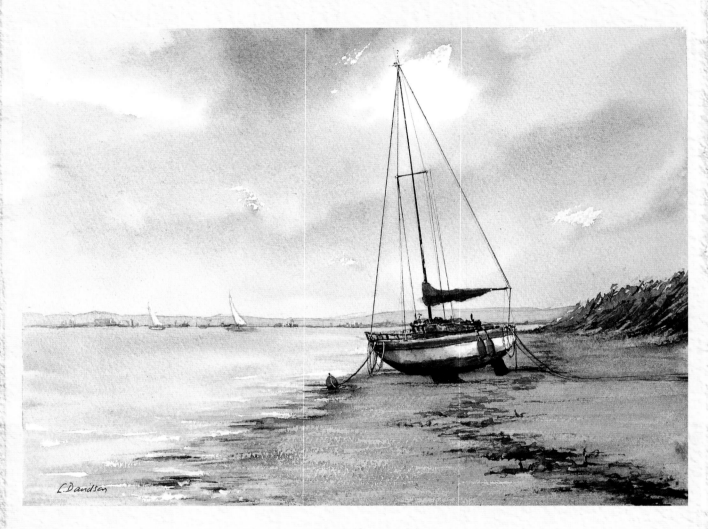

L.Davidson

COLOURS NEEDED

Ultramarine blue	Cerulean blue	Raw sienna	Burnt sienna	Burnt umber	Payne's grey

Cadmium yellow hue	Cadmium red hue	Cobalt blue	White gouache

I love this photo my daughter took of a catamaran moored up at low tide. However, the composition looks a little unbalanced as it is: the boat is too far over to the left and listing out of the picture; the sky is over-exposed and covering the scene with too much shadow; and, most importantly, the multi-hulled shape of the catamaran is complex. All of these present problems with painting the scene convincingly.

Artistic licence

It is at times like this that I use my 'artistic licence' to move things around, or change certain elements to create a pleasing and balanced composition. Remember, we are making a painting, trying to capture a mood or a moment in time, so we don't need to paint the scene precisely as it is in the photo.

I substituted the catamaran for a simple yacht and moved it to the right, where it more closely follows the rule of thirds (see page 18) and creates a more balanced composition. I simplified the distant shore and sand dune, and finally, I changed the weather to a fresh and sunny day, rather than the imposing clouds and shadows shown in the original photo.

Prepare your painting by sketching the scene onto watercolour paper, then tape it to your board and set it at a shallow angle of about 20 degrees.

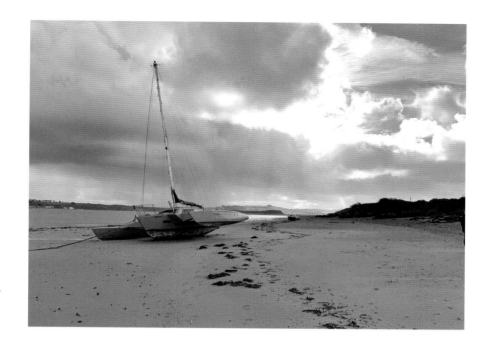

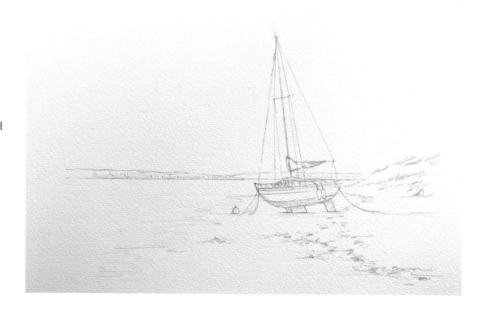

YOU WILL NEED

- *140lb (300gsm) cold pressed (NOT) watercolour paper*
- *HB or B pencil, ruler and eraser*
- *0.3mm waterproof black fineliner pen*
- *Painting board and masking tape*
- *Sponge and kitchen paper*
- *Palette with several large mixing wells*
- *Palette knife*
- *No. 14 mop brush*
- *Nos. 4 and 14 round brushes*
- *No. 2 rigger brush*
- *¾in (19mm) flat brush*
- *Small fan brush*

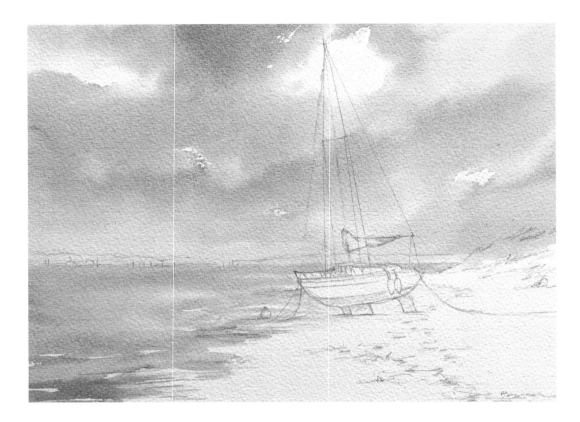

Use the tips of the flat brush to paint side-to-side brushstrokes that become finer as they meet the beach, creating a waterline.

STAGE 1

Paint in the sky and sea using the wet-in-wet technique (see page 22). Mix up a large well of light to mid-value ultramarine blue with plenty of water to make a bright summer sky colour. Wet most of the sky and sea, leaving a few dry patches for clouds. Let the water soak into the paper for 30 seconds or so, then wipe off any excess with a clean damp sponge.

Using the no. 14 mop brush and starting near the middle, paint the sky around the dry patches to leave some clouds. Push the brush around to keep the edges soft and spread the paint evenly, maintaining a slightly darker value towards the top of the paper. Allow the paint to become paler as you continue to paint the sky, bringing the colour down over the distant headland and towards the horizon. Change to the flat brush and paint the sea the same colour using horizontal brushstrokes, leaving a few unpainted wave crests near the foreground sand.

Rinse out the mop brush and squeeze the water out of the bristles so that it's only just damp, and soften any hard edges around the clouds. Leave to dry completely.

Tip
Make sure your brush is almost dry for softening the edges of the clouds; if it is too wet, it may cause cauliflower marks or runbacks (see page 22).

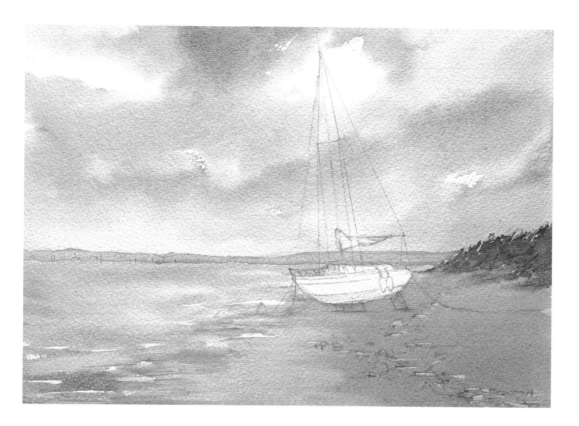

STAGE 2

Add a dab of raw sienna into the sky colour and a little water to keep the value light, and paint the distant headland with this muted green, using the flat brush.

Mix up a mid-value green with raw sienna, ultramarine blue and a dab of cerulean blue, and paint the grass on top of the sand dune with the no. 4 round brush, keeping the top a little ragged to suggest grasses. Add a touch more raw sienna and some burnt sienna, then paint the lower part of the dune with this earthier green.

Mix a large well of raw sienna with a small dab of ultramarine blue to neutralize the yellow slightly, then using the mop brush, paint the sand across the beach with horizontal brushstrokes, painting around the hull of the boat. You can safely paint through the keel and rudder as this will be darker. Feather this beach colour into the water on the left of the boat. Add a touch of burnt sienna and burnt umber to slightly darken the sand colour, and paint this across the right side of the beach. Allow this to blend wet-in-wet with the first sand colour.

Scrape a few small marks using a palette knife (see page 25) into the damp sand to create a base for painting the seaweed in Stage 4. Leave to dry.

Notice how the marks created with the palette knife for the seaweed become smaller as they recede into the distance.

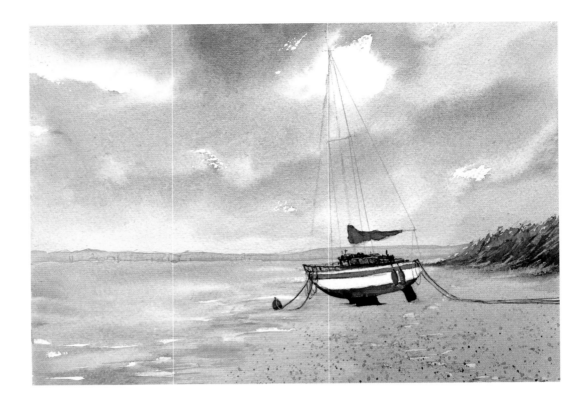

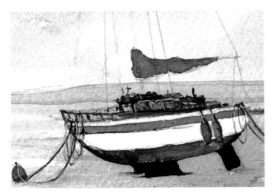

In this close-up of the painting, you can see the detail on the yacht more clearly.

STAGE 3

Mix a little dark value cobalt blue, and using the no. 4 round brush, paint the sail cover and a line of blue across the top of the boat's hull, leaving a narrow band of white above the blue.

Mix some dark value cadmium red hue with a little Payne's grey and paint the anti-fouling paint on the base of the hull, trying to achieve a slightly patchy, weathered look. Use dark value Payne's grey to colour the keels and rudder, the rail and the boat cabin, leaving the windows unpainted for now.

When completely dry, add a line of Payne's grey to the edge of the hull for shadows, and a few marks on the cabin roof to suggest miscellaneous items. Paint the windows with light value Payne's grey. Mix some strong, dark value cadmium red hue, and paint the fenders and buoy. Touch in a few dabs of cadmium red hue and cobalt blue on the roof and the back of the boat for more hints of suggested detail. Leave to dry.

Use a 0.3mm waterproof black fineliner pen and draw in the mooring ropes at either end of the boat. Add a few extra loops of rope. Mix a dark value green from cadmium yellow hue, cobalt blue and Payne's grey, and use this to add deeper shadows to the grasses in the dune. Leave this area to dry.

Finally, for texture, lay clean kitchen paper over the sea, boat and sky, then use the fan brush to spatter a few small spots of raw sienna and then burnt sienna onto the foreground beach. Remove the paper and leave to dry fully.

Tip
To create even spatter effects, mix the paint to an inky consistency, load the fan brush, hold it over the beach and tap the ferrule lightly with your finger to release the spatter drops.

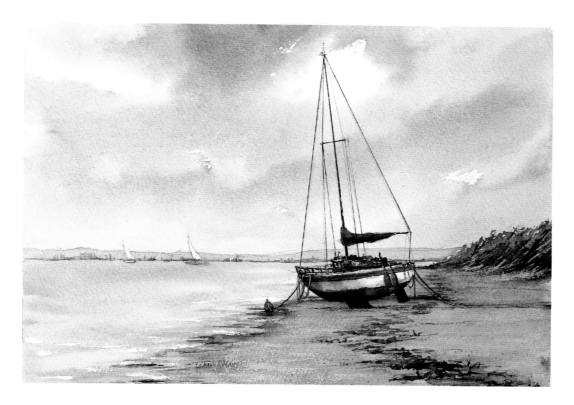

STAGE 4

Use a ruler and the 0.3mm black fineliner pen to carefully draw in the rigging.

Mix some light value grey using Payne's grey with a touch of cobalt blue. Paint a fine line across the base of the distant headland with the rigger brush, adding a few tiny vertical dashes to suggest distant boat masts, etc.

Create a light value purplish-grey shadow colour using cadmium red, ultramarine blue and a dab of Payne's grey. Using the no. 14 round brush, paint a shadow over two thirds of the hull.

Mix up a glaze (see page 23) of light value raw sienna and burnt sienna, and glaze over the whole beach with the mop brush to create the golden sands effect. Allow to dry completely.

Paint some white gouache highlights with the no. 4 round brush at the water's edge and across the wet sand. For an optional extra, add a couple of distant sailboats by painting a small, pale grey dash for each boat and a simple triangle in white gouache for each sail.

Mix a dark value reddish-brown from cadmium red and Payne's grey and use this to paint the seaweed with flattened, calligraphic brushwork (see page 25). You can swap between the round brush and the rigger brush to paint smaller marks, suggesting distance.

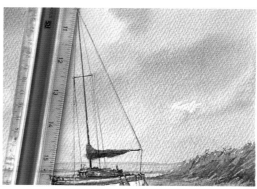

Using a pen and ruler to ink in the rigging takes away the stress of painting fine, straight lines. However, with practice, you will be able to use the rigger brush for its intended purpose: painting a ship's rigging.

Tip
If you can't see your rigging outline clearly through the sky wash, pencil it back in lightly before adding the ink.

FOCUS ON
Painting Trees

Trees are vastly important elements in landscape painting. The eye cannot help but be drawn to their statuesque trunks and their shapely canopies and branches.

Trees come in all manner of shapes and sizes, but in terms of composition they can simply be separated into three main types: foreground, middle-ground and distant trees. All will be painted with different degrees of detail.

Distant trees

You can suggest depth and distance in your work by painting faraway trees as long brushstrokes across the horizon line or on top of a hill. The context allows the viewer to interpret these shapes as either clusters or single trees depending on their size and position. Painting them with paler, cooler colours than those in the foreground will add to the effect of recession.

With loose watercolour painting, suggested detail in the distance is far more visually powerful than anything that looks too detailed or fussy.

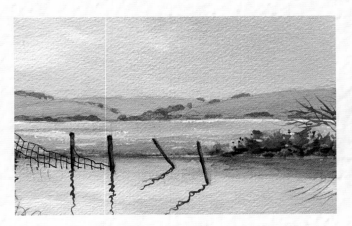

Middle-ground trees

Trees in the middle ground will be a little more detailed than those in the distance, and they sometimes serve as a subtle device to lead the viewer towards points of interest; for example, a tree-lined path or trees surrounding a farmhouse or cottage. You can often paint them into the first wash, so that the canopies soften and blur into the background as the paint dries. You can add a little more detail once dry.

Points of interest or focal points can sometimes be placed in the mid-ground; add a little more detail to objects in this area or use stronger tonal values to draw the eye.

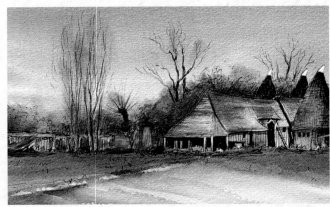

Foreground trees

In a loose painting style, trees in the foreground are still fairly simple, but they will have more detail and darker values than those in the middle ground and distance. You can exaggerate the direction of the branches to frame the view or to lead the eye into the painting. To create the foliage, you can use loose calligraphic brushwork (see page 25) in various colours; or paint a tangle of bare branches with a small round brush or rigger brush, according to the season being depicted.

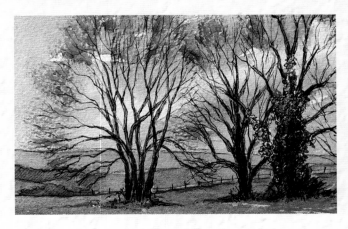

The changing seasons

Deciduous trees change with the seasons. Typically, they will show fresh green leaves in spring; darker, lusher greens in summer; mellow browns, yellows and oranges in autumn; and of course, the bare-branched trees in winter that are beloved by artists.

Coniferous trees keep their leaves all year round, but they can add so much to a scene in any season. Their leaves are often a darker, bluer green than their deciduous sisters, and they can be used to add depth and colour to winter scenes or depth and tone to other seasons.

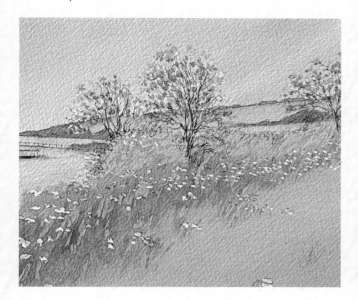

Keep spring greens fresh and light. Use more yellow in your green mixes, and keep foliage canopies a little less dense than in summer.

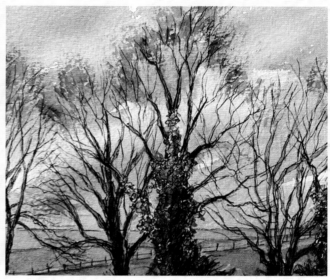

I like to keep a few greens in my autumn trees; they act as a wonderful complement to the warmer yellows, browns and oranges that feature in autumn colours.

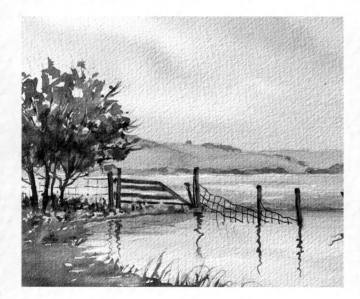

Summer foliage is lush, with darker greens and deeper shadows, as the canopies will be denser and allow less light through. Darker values and richer paint can be used here for the shadows.

Bare-branched winter trees work really well in paintings. Feather out your brushwork so it becomes finer and more abundant at the ends of the branches. Add a little dry brush over the tips to suggest the tiny twigs.

November Trees

Late autumn trees are wonderful things to paint: some bare-branched, others clad in a handful of dead leaves and ivy. To me, they always evoke a sense of wonder and the stark, austere loveliness that arrives with the onset of winter. This simple line and wash painting celebrates their stately beauty.

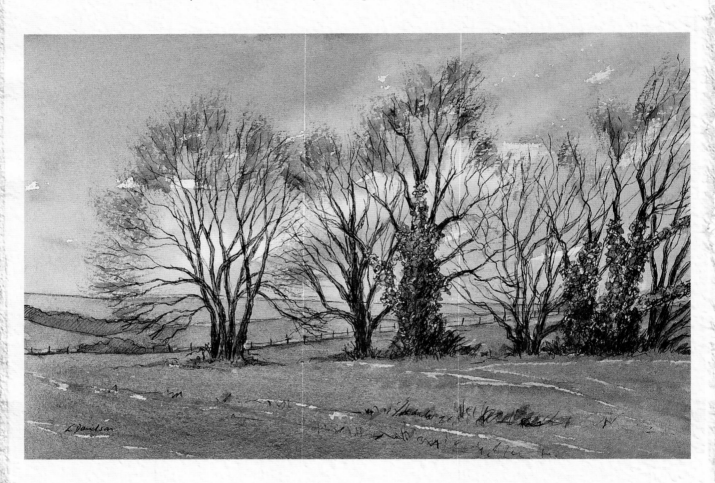

COLOURS NEEDED

Payne's grey	Raw sienna	Ultramarine blue	Burnt sienna	Burnt umber	Cadmium yellow hue
		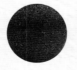			

The focus for this project is entirely upon these lovely ancient trees. The rest of the autumnal landscape is achieved through the use of colour and suggested shapes, serving as a backdrop for the tree's distinctive outlines, with the last handful of withered leaves still clinging to the ends of the boughs.

Follow the four-stage detailed linework process (see page 21) to sketch the scene in pencil and complete the linework and shading with waterproof fineliner pens.

Start by outlining the tree trunks and thicker branches with the 0.5mm fineliner, then switch to the 0.3mm for the finer branches. Notice how the branches taper off and become thinner as they grow further from the trunk, and how they split into many fine overlapping twigs near the edges. Apply less pressure to the pen as you reach the finer twigs for fainter marks.

Once the outline and shading are complete, tape the paper to your board and set it at a 20-degree angle.

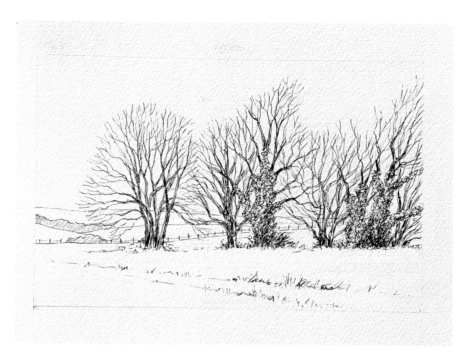

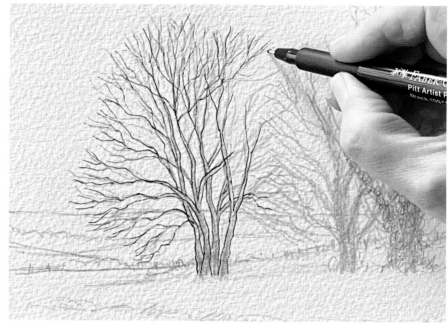

YOU WILL NEED

- 140lb (300gsm) cold pressed (NOT) watercolour paper
- HB or B pencil, ruler and eraser
- 0.3mm, 0.5mm and 0.7mm waterproof black fineliner pens

- Painting board and masking tape
- Sponge and kitchen paper
- Palette with several large mixing wells

- Palette knife
- No. 14 mop brush
- Nos. 4 and 14 round brushes

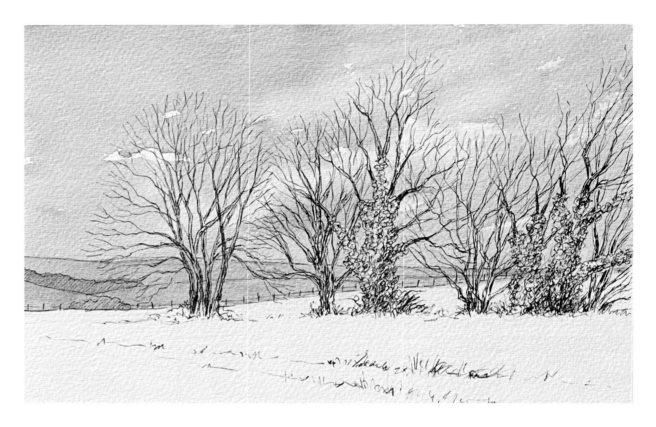

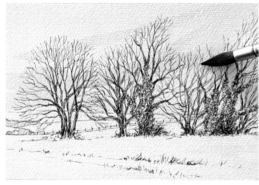

Paint the raw sienna over the trees rather than trying to paint around them.

Tip

When mixing greens, add small amounts of blue or Payne's grey to a larger amount of yellow, as the darker colour will overwhelm the yellow quickly if you add too much. Mix really well to fully combine the two colours and avoid little lumps of unmixed colour appearing in the painting.

STAGE 1

Paint the sky using the wet-on-dry technique (see page 22). To paint this sky, mix a well of light value raw sienna, and another of light to mid-value Payne's grey. Use the no. 14 mop brush to sweep a few brushstrokes of raw sienna across the sky, then quickly paint in the rest of the sky with Payne's grey, painting around the raw sienna and leaving a few unpainted patches for clouds. Bring the colour down as far as the top of the distant hill. Rinse the brush and squeeze all the water from it so that it is just damp, then soften any hard edges and spread the paint evenly around the sky. Leave to dry.

Mix a light value bluish-green using Payne's grey, cadmium yellow hue and raw sienna. Using the no. 14 round brush, paint the distant hill. While it is drying, mix up a slightly brighter light value green using ultramarine blue, cadmium yellow hue and raw sienna, and use this to paint the hill below. Paint over the small treeline on the left to darken it. Leave to dry.

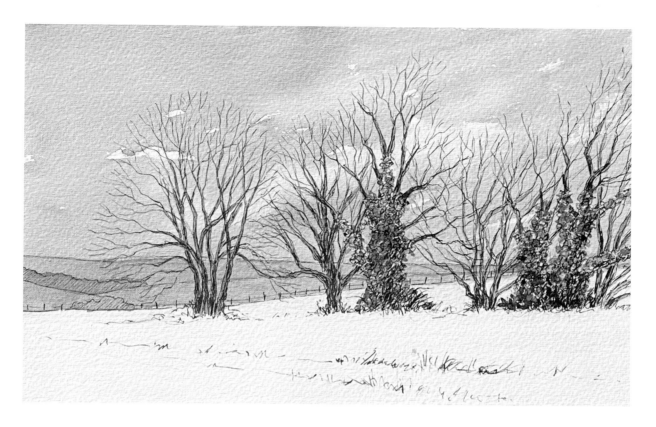

STAGE 2

Mix a mid-value well of burnt umber and paint the tree trunks and thicker branches, using the tip of the no. 4 round brush.

Now paint the ivy. Mix up three colours: a mid-value green using ultramarine blue, cadmium yellow hue and raw sienna; a mid-value well of cadmium yellow hue; and a reddish-brown colour made from ultramarine blue and burnt sienna.

Swap between these three colours to paint the ivy using the no. 4 round brush, letting it blend here and there on the page. Dab out anything too dark or blobby with absorbent kitchen paper, and leave to dry.

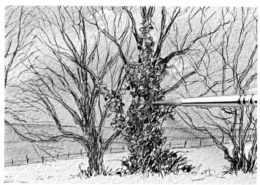

As you dot in the ivy colours with the no. 4 round brush, try to keep the ivy a more yellow hue towards the top, and darker towards the bottom and on the right for the shaded side of the trees.

Tip
Use a piece of absorbent kitchen paper to lift some wet paint if things start to look a bit too dark, then add some lighter green or yellow.

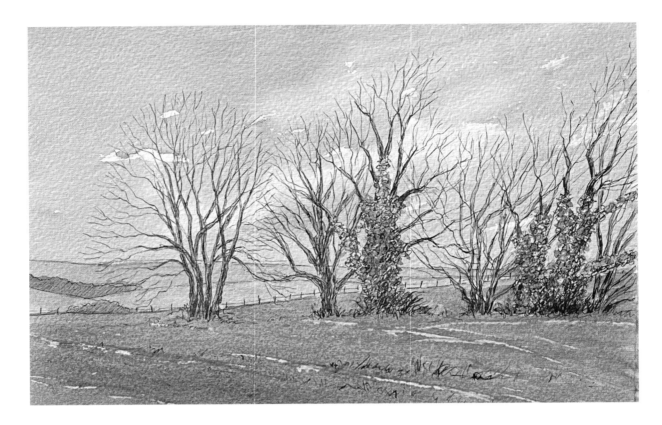

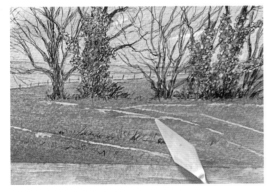

Wait until the paint is just damp before scraping these lines into the foreground. If it is too wet, the paint will flow back into the marks as it dries.

STAGE 3

Mix up a large well of mid-value green from ultramarine blue, cadmium yellow hue and raw sienna. Using the mop brush, sweep it across the foreground, then add it carefully behind the trees. You must work quickly to keep the wash smooth.

While the foreground is still wet, mix up some mid-value raw sienna and sweep it across in a shallow diagonal, then mix up some mid-value burnt umber and sweep it under the trees and across the bottom left corner. It should all blend nicely on the page to give a beautiful, earthy winter green, with varying shades to suggest a loose foreground.

Allow the paint to settle for a moment, then just before it dries, use the palette knife to scrape a few shallow diagonal lines through the damp paint in the foreground. Use your finger to lightly smudge paint over any marks that look too large. Leave to dry.

Tip

The burnt umber across the bottom left corner adds shadow and also acts as a framing device to lead the eye into the painting.

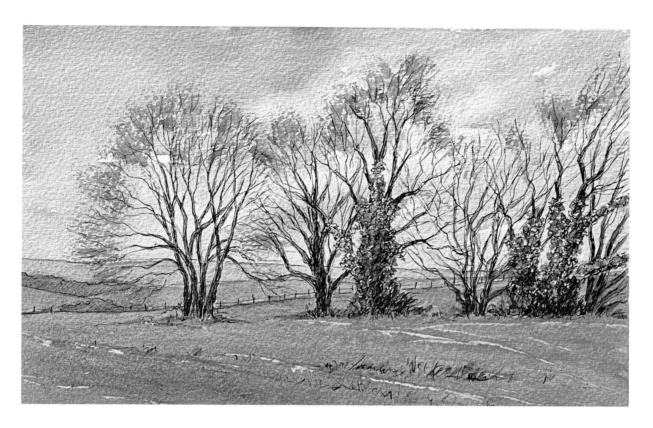

STAGE 4

Mix up a dryish puddle of mid-value burnt umber and dip the mop brush into it. Dab onto a piece of absorbent kitchen paper to remove excess water, leaving quite dry paint on the brush.

Paint dry brushstrokes (see page 25) over the fine branches at the ends of the canopies, giving the illusion of twigs and a few remaining leaves. Add a touch of Payne's grey to the burnt umber mix and darken a few of the dry brushstrokes.

Using the same mix of burnt umber and Payne's grey, darken up the tree trunks using the no. 4 round brush. Repeat around the bases of the ivy-covered trees and on the shaded sides on the right. Leave to dry completely.

If some of the fineliner twigs look a little pale beneath the washes, once the painting is bone dry, carefully draw over them with the 0.3mm fineliner.

Drift the belly of the brush across the texture of the paper to get subtle dry brush effects.

Tip

Test the brush on a scrap of paper to make sure you are getting dry brush marks. If it is too wet, dab on a piece of absorbent kitchen paper and test again.

Windmill in the Snow

Windmills are lovely subjects to paint, and this mill – with its attractive white sails and contrasting black cap and windows – creates a wonderful point of interest in this winter snow scene.

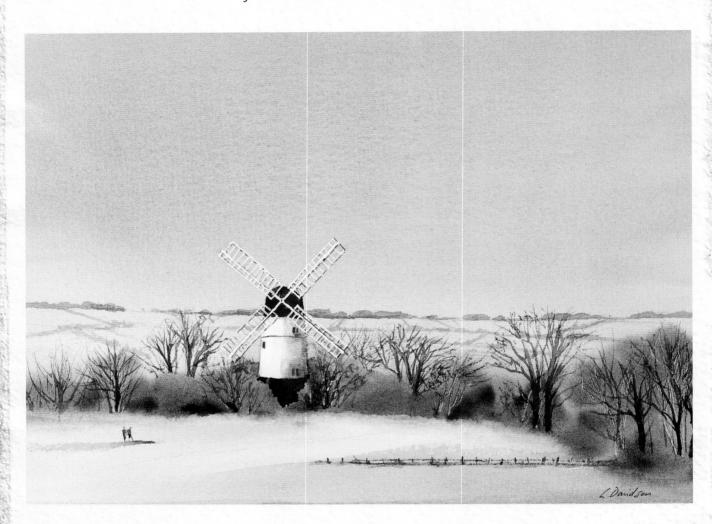

COLOURS NEEDED

Indigo	Lavender blue	Burnt sienna	Burnt umber	Payne's grey

For this project, you will be using the same colour palette to create the grey sky and the snowy ground. This will enhance the painting's atmosphere, offering the impression of newly fallen snow, with the sky above heavy with the promise of more on the way. The addition of lavender blue for this piece adds a touch of opacity to the transparent watercolour, which helps achieve this effect.

Draw out the windmill outline lightly with an HB or B pencil onto watercolour paper, taking care to ensure the sails are as accurate as you can make them.

Resist technique

You can use a 'resist' technique to help the windmill's sails stand out. A white acrylic fineliner pen will give you greater control for this than using masking fluid with a brush.

Draw over the pencil outline with the white fineliner; the acrylic ink is waterproof once dry, so it acts as a 'resist' and will show through the sky wash. This gives a more subtle effect than masking. Alternatively, you can apply masking fluid (see page 24), using a small brush for the sails and painting over the pencil outline. Allow it to fully dry before applying paint.

Tape the linework onto the board and prop it at an angle of 20 degrees.

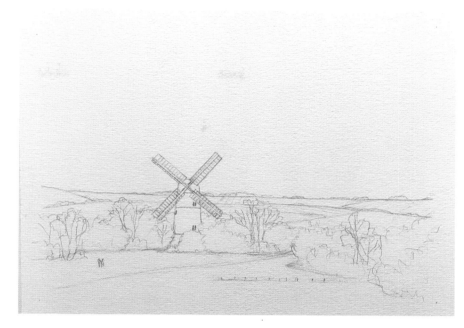

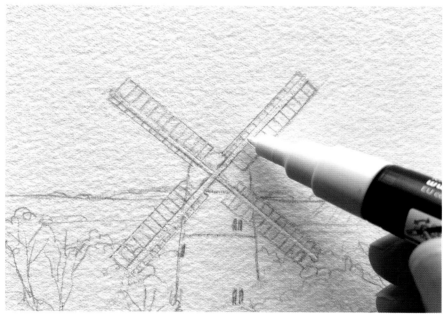

YOU WILL NEED

- 140lb (300gsm) cold pressed (NOT) watercolour paper
- HB or B pencil, ruler and eraser
- 0.7mm waterproof white acrylic fineliner pen, or masking fluid and an old, small brush

- 0.3mm waterproof black fineliner pen
- Painting board and masking tape
- Sponge and paper
- Palette with several large mixing wells

- Palette knife
- No. 14 mop brush
- 1½in (38mm) mottler brush
- No. 4 round brush
- No. 2 rigger brush
- ¾in (19mm) flat brush

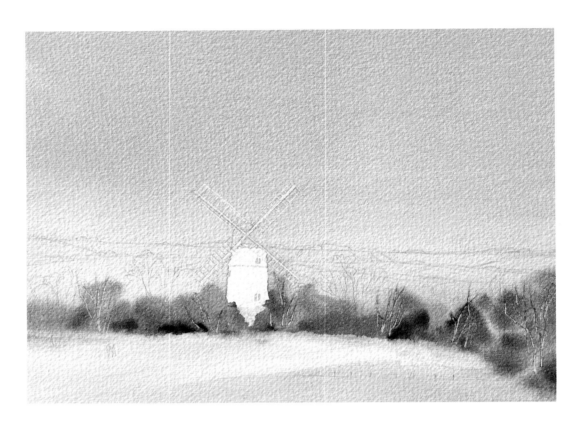

The palette knife can scrape through the damp paint to reveal the white paper, giving the suggestion of highlights on the trunks and branches.

STAGE 1

Paint the sky and land using the wet-in-wet technique (see page 22). Mix up a light to mid-value well of indigo and lavender blue, making enough to cover the paper. Except for the mill building, use the mottler brush to wet the whole paper with clean water. Allow the water to soak into the paper for 30 seconds or so before wiping away any excess with a clean, damp sponge.

Starting at the top, use the mottler brush to paint a graduated wash (see page 23) that is darker across the sky, lighter above the hill and over the land, and darker again towards the bottom of the page. Paint around the mill building to preserve the white paper.

Make separate mid-value mixes of Payne's grey, burnt umber and burnt sienna using less water than the sky wash, then paint into the wet wash along the treeline with the mop brush, using soft, dabbing brushstrokes and alternating between the three colours to create the impression of softly diffused shrubs and trees.

Rinse the mop brush, squeeze all the water from it and lift out a lighter patch in the snow for the path, then sweep some of the darker sky colour below this in a shallow diagonal for some slight contrast.

Take the palette knife and scrape a few trunks and branches into the treeline. Leave to dry.

Tip
Use a clean, damp flat brush and drag the tips lightly across the base of the tree line to clean up the edge.

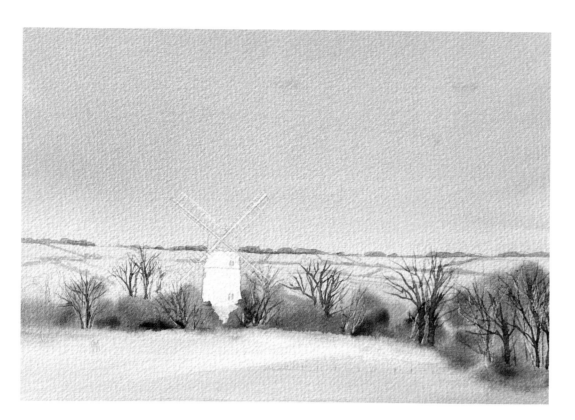

STAGE 2

Mix up a light value grey from Payne's grey with a dab of burnt umber, then using the no. 4 round brush, paint the distant trees and the field boundaries on the hill behind the mill.

Mix up some darker value Payne's grey and burnt umber to make a deep brownish-grey, then paint the bare winter trees around the mill with the rigger brush, taking care to keep the branches as fine as possible around the edges. Paint some with full trunks, and others emerging from behind shrubs to add variety.

Make sure you work around the marks you scraped in with the palette knife during Stage 1 and try to integrate them with the rigger brushwork. Leave to dry.

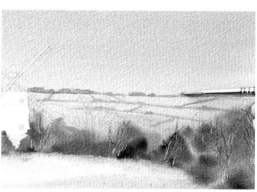

The mix for painting the faraway trees and field boundaries should be quite pale to suggest distance.

Tip

Don't worry if the marks made with the rigger brush get a bit wayward – this all helps to suggest a fine tangle of branches and twigs.

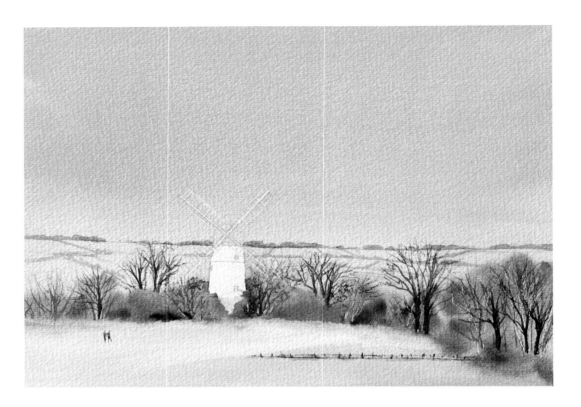

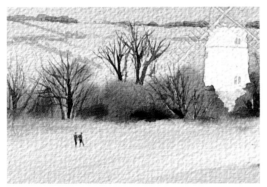

Keep the figures quite small to show the scale of the windmill.

STAGE 3

Mix a small amount of dark value Payne's grey, and using the tip of the no. 4 round brush, paint a few tiny marks to suggest the pair of figures on the left. Observe the detail photo before painting them to see how few marks I have made; you are trying to create an impression of these figures and not details. A few dabs of paint for the bodies and a pair of dots for their heads will suffice. Next, with the same mix, but this time using the rigger brush, paint the little fence emerging from the trees with two parallel horizontal lines and little dashes for fence posts.

Paint a little light value lavender blue below the fence and gently smudge it with your finger to blend, to give the impression of snow and shadows beneath the fence.

Still using the rigger, add a few more shrubs and trees with Payne's grey to fill them out a little more. Leave to dry.

Tip
Touch the point of the brush very lightly to paint the tiny fence posts.

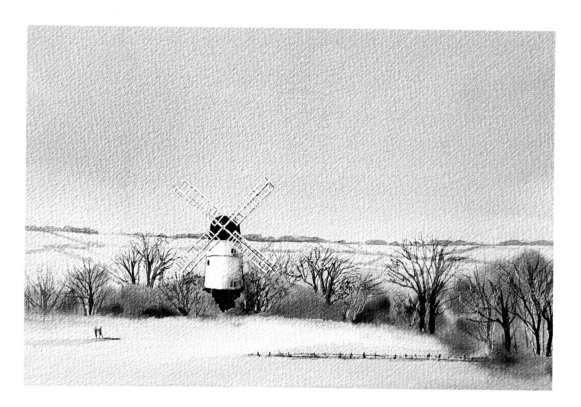

STAGE 4

If you used masking fluid for the sails, leave it in place. However, if you used the acrylic ink resist technique, draw over the sails once more with the 0.7mm white acrylic pen to strengthen the white lines.

Mix up a dark value Payne's grey for the black dome of the mill. If you used masking fluid, paint straight over the sails; if you used acrylic ink resist, paint carefully around them using the no. 4 round brush. Paint the windows and the black base of the mill and leave to dry.

If you used masking fluid, once the dome is bone dry, dab the sails with a piece of absorbent kitchen paper to remove any damp paint from the masking fluid surface, then gently rub away the masking fluid with a clean fingertip.

Take the 0.3mm fineliner pen and add a few shadows here and there on the white sails.

Using the no. 4 round brush, add shadows and the impression of footprints below the figures with a mix of light value Payne's grey and lavender, and finally, using the flat brush, paint a light value mix of indigo and lavender across the shadow side of the mill. Leave to dry.

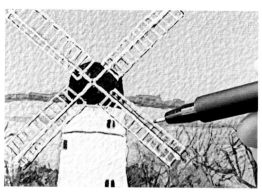

If you accidentally paint over the sails in places, you can go over them with more white fineliner when the paint is dry, adding shadows with the 0.3mm black pen.

Tip

Lightly dab the shadow with a piece of absorbent kitchen paper to soften the edge where it meets the white paper.

Old Farm in Midwinter

*Rural buildings can make wonderful subjects for landscape paintings,
and these ancient hop farm buildings are very picturesque,
filled with old-world charm.*

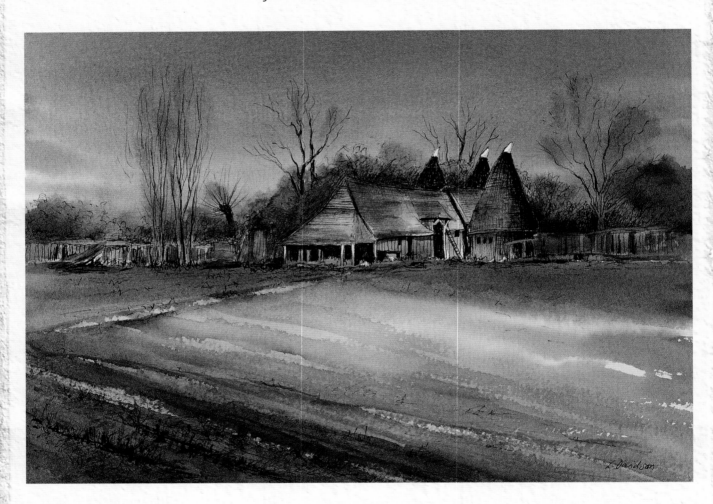

COLOURS NEEDED

Burnt umber	Indigo	Payne's grey	Burnt sienna	Venetian red	White gouache

Sometimes it can be refreshing to stray from local or realistic colours and explore different ways of creating interest and atmosphere in paintings. A good way to work out what kind of colours work well is to sketch out the scene a couple of times really roughly in ink, then try a different combination of colours on each.

After some thought, I decided to try and convey the starkness of midwinter and the low light produced by the shorter days using the more subdued palette of browns and greys, which I think complements the scene. This scene could just as easily be painted using vibrant autumnal colours or fresh spring greens. Quick colour sketches like this are a good way of exploring the many possibilities for using your artistic licence.

This line and wash painting (see page 21) uses inked linework to provide much of the detail and values. Begin with the four-stage detailed linework process. The washes of paint that follow will bring atmosphere and life to the ink drawing.

Tape the linework onto the board and prop it at an angle of 20 degrees.

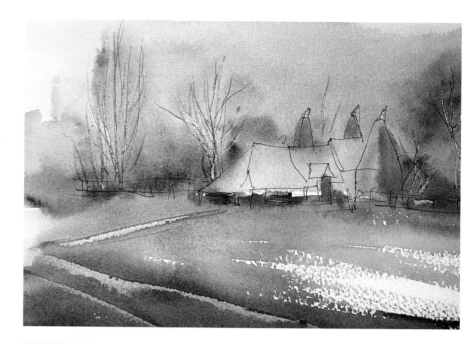

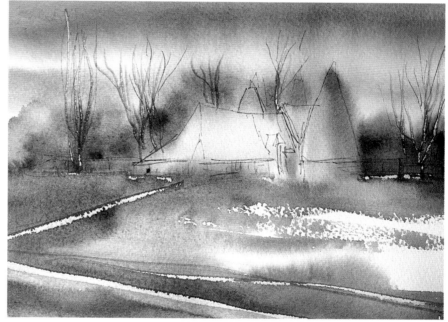

YOU WILL NEED

- *140lb (300gsm) cold pressed (NOT) watercolour paper*
- *Sketchbook or sketching paper*
- *HB or B pencil, ruler and eraser*
- *0.3mm, 0.5mm and 0.7mm waterproof black fineliner pens*
- *Painting board and masking tape*
- *Sponge and kitchen paper*
- *Palette with several large mixing wells*
- *Palette knife*
- *No. 14 mop brush*
- *No. 4 round brush*
- *¾in (19mm) flat brush*

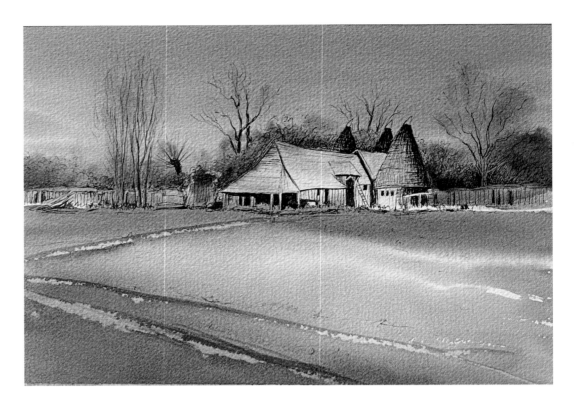

Painting the bottom edge or corners darker helps to frame the composition and draws attention to the focal point.

Tip
Adding these colours to the wet wash means they will soften and diffuse, which will complement the sketchy linework trees.

STAGE 1

Paint this stage using the wet-in-wet technique (see page 22). Mix a mid-value brownish-grey from Payne's grey, burnt umber and a dab of indigo, then wet the paper all over with the mop brush and leave for around 30 seconds to soak in. Using horizontal brushstrokes, paint a grey sky. Start at the top and work down, leaving a few thin strips unpainted roughly halfway down the sky, and continue with the wash, painting over the conical hop kilns, barn roofs and the fence in a few places.

Add a little more burnt umber to the mix and paint the land, sweeping the brush horizontally under the buildings, then in a shallow diagonal stroke from middle left, leaving some unpainted paper. Finish with darker paint over the bottom left corner.

Mix up a well of mid-value burnt sienna, a well of mid-value indigo and a well of mid-value burnt umber. Mix them with less water than the sky wash to avoid runbacks (see page 22). Dab these colours in random patches around the treeline, still using the mop brush. Allow the paint to go over the edges of the linework in places; this gives lovely loose effects with lost edges.

Finally, using the palette knife, lift out a few long, thin marks across the middle and foreground by scraping through the paint back to the white paper (see page 25). Start from below the barn, then sweep diagonally towards the lower left corner to suggest a path. Leave to dry completely.

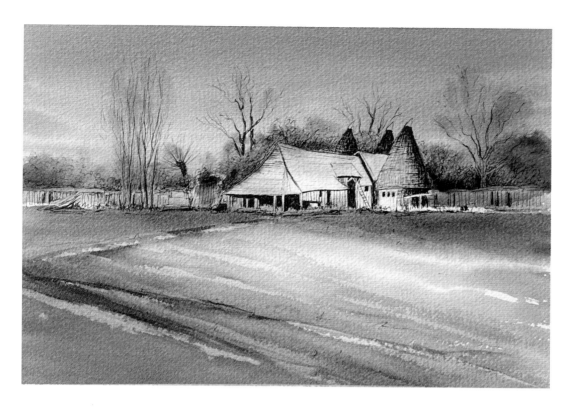

STAGE 2

Mix a light to mid-value mix of burnt umber, and a light to mid-value mix of indigo in separate wells. Using the mop brush, paint horizontal brushstrokes below the buildings and fences, starting with burnt umber and then painting into the wash with indigo.

Lightly skim more burnt umber over the central field area on the right of the path to start the suggestion of furrows.

Dip back into the indigo, still using the mop brush, and paint the bottom right corner and a few darker furrows. Add a little Payne's grey if it doesn't look quite dark enough. Leave to dry.

Using the belly of the mop brush to achieve some dry brush marks (see page 25) will make the furrows look more convincing.

Tip

Try to get used to painting a little darker than you want your work to look, as watercolour always dries about 30 per cent lighter than it looks when applied.

A glaze of indigo and Payne's grey will darken and intensify the framing effect painted across the bottom left corner in Stage 1.

STAGE 3

Now paint the fence and suggestions of farm equipment and paraphernalia. Mix up a mid-value mixture of burnt sienna with a dab of burnt umber to darken it slightly, and using the no. 4 round brush, add a few dabs of colour along the fence here and there, on either side of the barn and kilns, to suggest piles of logs and other farm debris.

Mix up a mid-value glaze of indigo with a dab of Payne's grey, and glaze (see page 23) over the bottom left corner again with the mop brush. Leave the painting to dry.

Tip

Leave some of the underpainting showing through when you paint the fences, etc.

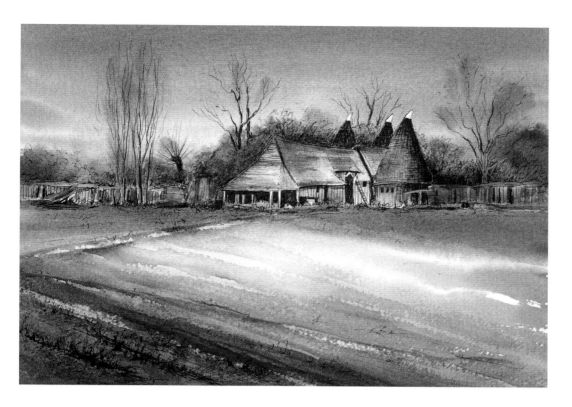

STAGE 4

Create a dark value mix of burnt sienna with a touch of burnt umber, and a separate mix of Payne's grey with a small dab of Venetian red. Paint the barn roofs with the burnt sienna mix using the flat brush and add a touch of burnt umber here and there while it is wet to achieve a weathered look. Paint the hop kilns with the Payne's grey and Venetian red mix. Dab off with a piece of absorbent kitchen paper if it looks too dark.

While it is drying, make up a light value mix of indigo and Payne's grey to create a pale grey, and use the no. 4 round brush to paint the barn walls and wood cladding on the roof.

Take the 0.5mm black fineliner and add some scribbly marks in the bottom left foreground to suggest stubble, then add a little light value burnt sienna using the no. 4 round brush.

Add some extra shading with the fineliner across the land underneath the building.

Finally, mix up some white gouache, and with the tip of the no. 4 round brush, paint in the cowls on top of the hop kilns. Leave to dry.

Allow the burnt sienna and burnt umber to blend wet-in-wet on the roofs to get a patchy, weathered effect.

Tip
A little burnt sienna around the fineliner stubble marks will warm it up and bed it into the painting nicely.

FOCUS ON
Painting Water

Whether it's a tempestuous stormy sea, a calm tropical beach, a peaceful tree-lined lake, a raging river, or even just puddles in the furrows of a field or country lane, water always makes an evocative addition to a landscape painting.

For painting, it can be helpful to categorize types of water into 'still water' and 'moving water', as different techniques will be used to suggest the effects of each.

Still water

When water is still it is reflective like a mirror. It will often reflect the colours and shapes in the sky above such as cloud patterns or birds in flight. A good way to capture this effect very simply is to paint the water with the same colours as the sky, loosely echoing any cloud and shadow you choose to include. A wet-in-wet graduated wash (see pages 22 and 23) that mirrors your choice of sky colours will be very effective at suggesting the flat surface of a still pool or lake.

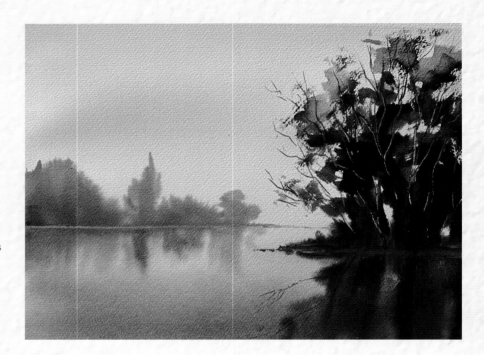

The sky and lake in this painting were painted using a graduated wash of raw sienna and Payne's grey. The trees, banks and reflections were added to the wet wash with darker, richer paint. The reflections were pulled down with vertical brushstrokes while the paint was still wet, and then allowed to soften and diffuse. Finally, some crisper detail was added to bring the painting together.

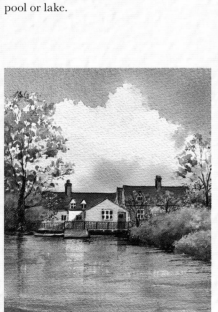

This painting of Flatford Millpond uses linework as well as paint and water to create the illusion of reflections. There are a few ripples, too, suggesting some slight movement or 'wind ruffle' on the surface, which was done through the use of horizontal linework and both vertical and horizontal brushwork.

The water in this harbour scene has a little movement from the tide, so the reflections are apparent but less distinct than in the examples on the opposite page. Some dry brushstrokes across the surface suggest light sparkling on the water.

Moving water

If you observe moving water, you will find that it does not reflect objects in the same way that still water does, and you will see that stormy water shows no reflections at all. Using dynamic brushstrokes can help to create a sense of movement in a stormy sea. Another method for achieving these effects is to apply layers of different glazes (see page 23). The examples below show a few of the many ways of creating energy, life and movement in water.

The movement in the seawater surrounding this coastal town was painted using layers. A light wash was painted first with indigo and a little burnt sienna to reflect the sky. This was allowed to dry and followed by successive wet-on-dry horizontal brushstrokes (see page 22), working from light to dark, to suggest movement on the surface of the water.

The wave breaking over the sea wall in this dynamic composition was created by leaving the large wave shape unpainted, then negatively painting the wall around it, adding lots of dark contrast. Finally, I added the pale shadows and textures in the wave itself. The water below the wall was painted in the same way as the water in the previous example.

Directional elements in the composition and brushwork contribute towards the movement and energy in this seascape. Movement is created by painting the leaning boats with the wind in their sails against a wild sky. Painting the wave crests with opaque white gouache over rough, calligraphic brushwork (see page 25) gives the illusion of waves and sea spray.

Misty Pine Forest at Dusk

Painting with a limited palette can create unusual yet harmonious works of art. Here, the soft greys of twilight are created using just two colours, while the lost and found edges enhance this painting's serene, misty atmosphere.

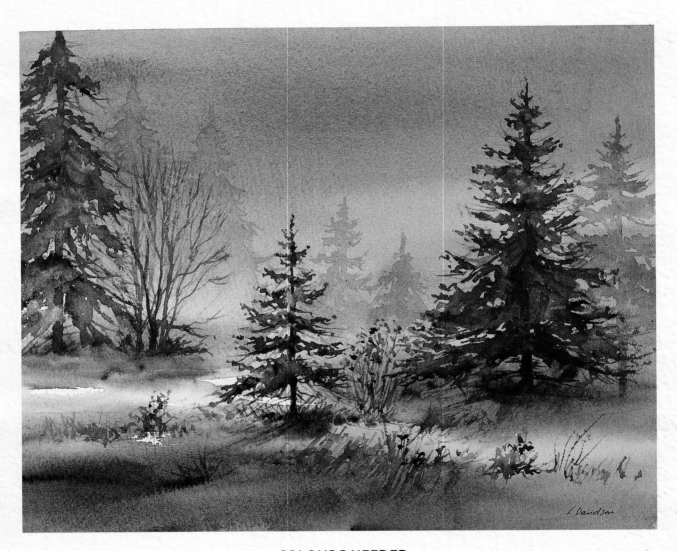

COLOURS NEEDED

Indigo

Burnt sienna

Creating misty effects

Mist and fog are wonderful things to paint. Whether it be an evening fog slowly wreathing a lonely forest or a sea mist rolling in across a quiet ocean, they are literally atmospheric! Watercolour is the ideal medium for creating these effects as, with its translucent qualities, it lends itself quite naturally to the subtle layering necessary for these kinds of ethereal landscapes.

Misty effects can be created by using more neutral or desaturated colours that are similar in tone. If you soften some edges and leave others sharp, the 'softened' parts will become lost in the background. Painting objects paler, using lighter value colours, will help to give the illusion of distance and of disappearing into the mist.

You can sometimes emphasize distance by using linear and aerial perspective (see page 19), as in this example of the bridge merging with the city skyline (see bottom right). The lights and structures get closer together, becoming paler and indistinct.

For this project, we will paint the background and the darker value trees first, then paint the soft-edged light value trees, softening them as we go and 'losing' their edges into the misty background to a lesser or greater degree.

Sketch the scene in pencil first, then tape the paper to your board and set it at an angle of about 20 degrees.

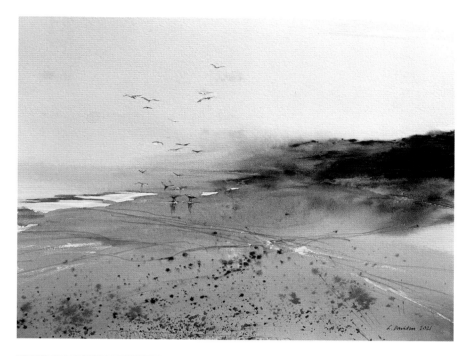

YOU WILL NEED

- *140lb (300gsm) cold pressed (NOT) watercolour paper*
- *HB or B pencil, ruler and eraser*
- *Painting board and masking tape*
- *Sponge and kitchen paper*
- *Palette with several large mixing wells*
- *No. 14 mop brush*
- *1½in (38mm) mottler brush*
- *No. 2 rigger brush*
- *¾in (19mm) flat brush*

Paint the wash using the flat belly of the mottler brush to cover the paper with as few brushstrokes as possible for a smooth finish.

STAGE 1

Paint this stage using the wet-in-wet technique (see page 22). Mix a large well of mid-value indigo and a separate small well of mid-value burnt sienna. Make sure you mix enough indigo for the whole page.

Wet the paper all over with the mottler brush, leaving a few dry patches on the path, then leave for around 30 seconds to soak in. Paint a graduated wash of indigo (see page 23) using horizontal brushstrokes, taking care to paint it darker at the top, lighter in the middle and darker again at the bottom, painting around the dry patches on the path. Add some mid-value burnt sienna across the middle ground and foreground.

Mix up two separate wells of dark value burnt sienna and indigo. Make sure this paint is thicker and richer than your mid-value paint, so that it shows up strongly on the wet wash. Use the flat brush to add dabs of these colours into the ground wash. Leave to dry.

Tip
The richer, drier paint added with the flat brush will diffuse less and add tone to the wash; it will also softly blend to provide a base for the forest.

STAGE 2

The only brush you will need for this stage is the rigger brush. Add more water to the dark-value paint mixes used for the previous stage until you reach an inky consistency. Begin to paint each tree, beginning at the top, using indigo. Take advantage of the rigger's flexibility to add delicate, wriggly, calligraphic brushwork (see page 25) while you're placing branches on either side of the trunk. Every now and again, dip into the burnt sienna and let this blend wet-in-wet with the indigo.

As you paint the lower branches, use bolder brushwork to suggest the larger, heavier boughs. Dab with a piece of absorbent kitchen paper to add texture and lift a little paint; this will help to suggest the misty effect.

As you paint from the top to the bottom, increase the size of each bough. When you get near the ground, paint the trunk with a few loose, straggly branches; then repeat this process for the other two main trees.

As it is a younger tree, keep the brushwork for the middle tree smaller in scale. For the far-left tree, as it is a little further away, dab out more paint with the kitchen paper. Note that the branches slope downwards in this case, as opposed to upwards like the other two.

Finally, add lots of tiny brushstrokes over and between the branches to suggest a tangle of smaller twigs. Leave to dry.

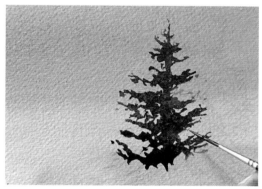

When adding burnt sienna, just touch the tip of the rigger brush into the wet indigo to allow it to run and wet blend on the page.

Tip

Paint the branches smaller at the top and allow more of the thin trunk to show through.

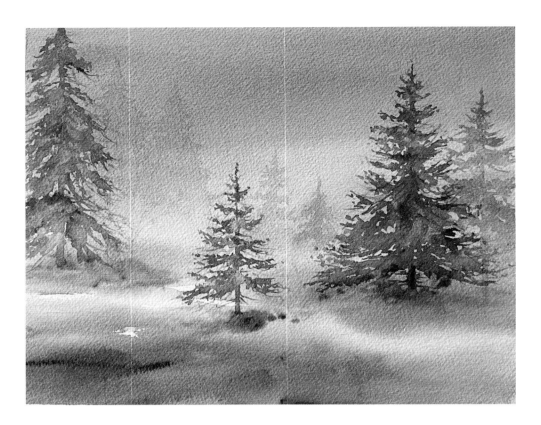

STAGE 3

Continuing with the rigger brush, paint the misty background trees using a very light value mix of indigo with a dab of burnt sienna: it should look just like tinted water. About one third of the way down, swap to the mop brush and wash in the rough shape of the tree, then dab with a piece of kitchen paper to 'lose' the bottom part of the tree in the mist.

Repeat until all the background trees are painted. As it is a little closer than the others, keep the one on the far right slightly darker. Leave to dry.

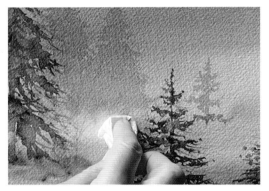

Lift some paint from the bases of the background trees with a piece of kitchen paper to soften the mist transitions.

Tip
Changing from the rigger to the mop brush to paint the body of the tree increases the misty effect, as it gives less detail.

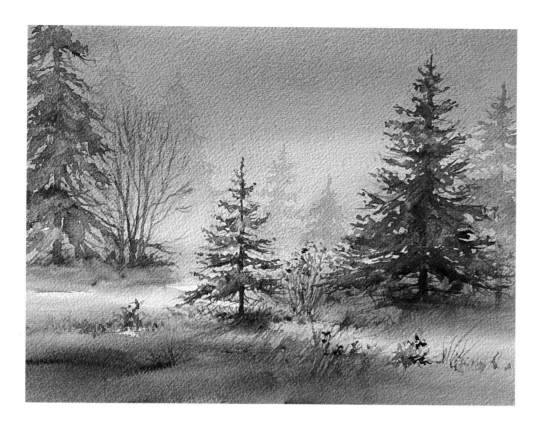

STAGE 4

If needed, mix more light to mid-value of indigo and burnt sienna in separate wells. Paint the slender, bare-branched deciduous tree on the left with the rigger, which will contrast nicely with the pines. Alternate between indigo and burnt sienna for some of the flowers and plants to add more interest to the foreground. Add some grasses, small clumps of plants and flowers to the forest floor. Weave around the tree trunks with little lines, flicks and dots for suggestions of flowers and seed heads. Leave to dry completely.

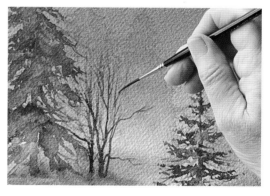

Keep your brushwork very fine for the slender bare-branched trees.

Tip

This scene could be painted with more natural colours, but keep them muted and desaturated to capture the evening light.

Flatford Mill

Flatford Mill, which is closely associated with the landscape painter John Constable, is loved by artists and has been painted many times over the years. Back in the day, the iconic buildings and mill pond would have been a hive of activity in the summer.

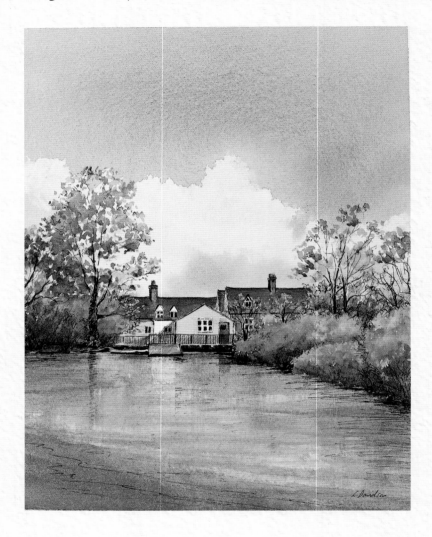

COLOURS NEEDED

Cerulean blue	Ultramarine blue	Raw sienna	Burnt sienna	Burnt umber	Lemon yellow

For this project, I have chosen to paint in portrait format rather than the more generally used landscape format. This vertical orientation helps to showcase the clear blue sky, fluffy white clouds and the gently ruffled water.

This project also offers ample opportunity to practise painting simple but effective buildings and drawing reflections, with the low mill building and surrounding foliage mirrored in the water below.

Sketch the scene in portrait format using HB or B pencil. Draw in the linework and shading using waterproof fineliner pens, following the four-stage instructions for detailed linework process (see page 21).

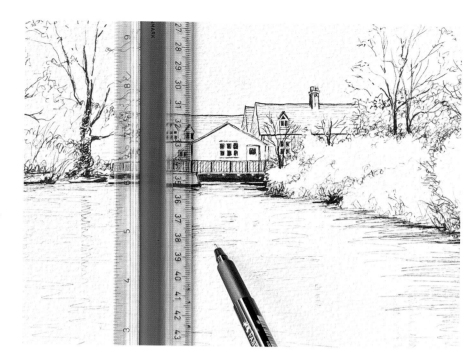

Reflections

I used the following technique for positioning the reflections. Line up the edge of a ruler vertically with the edge of one of the buildings and lightly pencil in a few vertical dotted lines. Repeat for all the main buildings and tree, making sure all lines look straight. Lightly hatch (see page 20) a few short, horizontal lines with the 0.3mm fineliner, using the dots as starting points. Keep the lines short, sketchy and faint, mirroring the position of the edges of the buildings and tree. They will indicate the position of the reflections and add a little structure and directionality.

Set the painting board up at a shallow angle of roughly 20 degrees.

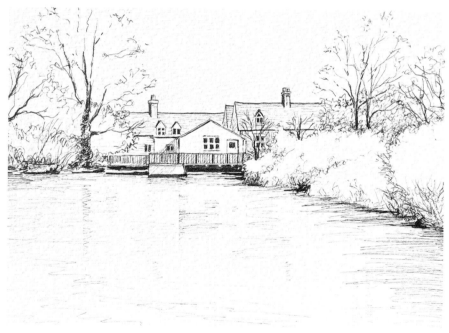

YOU WILL NEED

- *140lb (300gsm) cold pressed (NOT) watercolour paper*
- *HB or B pencil, ruler and eraser*
- *0.3mm, 0.5mm and 0.7mm waterproof black fineliner pens*

- *Painting board and masking tape*
- *Sponge and kitchen paper*
- *Palette with several large mixing wells*

- *No. 14 mop brush*
- *1½in (38mm) mottler brush*
- *No. 4 round brush*
- *¾in (19mm) flat brush*

The light value raw sienna adds a bright, sunny glow, as well as giving a little shape and form to parts of the clouds.

When lifting clouds with a paper towel, dab gently and carefully to avoid lifting too much paint. Go slowly and stop as soon as you like the look of the cloud shapes.

Tip
Wipe the masking tape clean after a large wash like this to ensure that any puddles of excess water don't run back into the wash as it dries, causing unsightly marks.

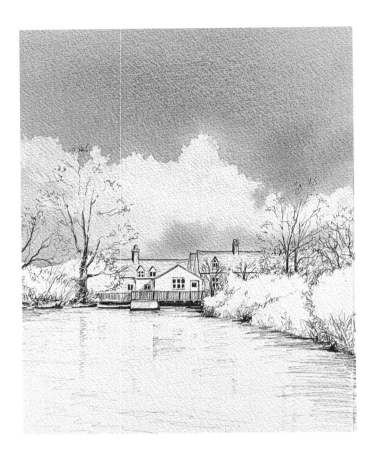

STAGE 1

Paint the sky using the wet-in-wet technique (see page 22). Mix up a small well of light value raw sienna, and a large well of mid-value cerulean blue and ultramarine blue. Mix enough blue for the whole sky.

Wet the sky with the mottler brush, bringing the water all the way down to the outlines of the rooftops. Let the paper soak for 30 seconds or so, then remove any excess water with a clean damp sponge.

Brush a little light value raw sienna across the lower part of the sky using the mop brush. Next, load it full of the blue mix and paint a flat wash (see page 23), beginning at the top of the paper and continuing until you reach the level of the treetops. Paint around some loose cloud shapes before continuing with the wash, stopping at the rooftops. Using the scrunched-up corner of a clean piece of absorbent kitchen paper, gently lift out some fluffy cloud shapes from the edge of the blue wash. Once you are happy with the clouds, leave the sky to dry completely.

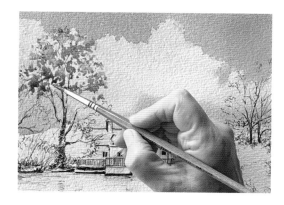

The darker green will blend wet-in-wet with the lighter green to add shadow and form.

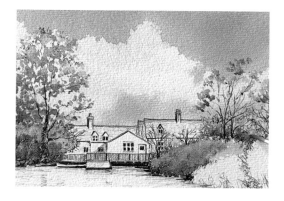

Paint the shadows in the shrubs, keeping them lighter and brighter across the top and middle to suggest sunlight catching the leaves.

STAGE 2

Mix up a small amount of pure mid-value lemon yellow as well as two different shades of green: a light green made from ultramarine blue and lemon yellow; and a slightly darker, earthy green using a touch more blue and a dab of burnt sienna.

Using the no. 4 round brush, paint the foliage of the largest tree using little dotting and dabbing brushstrokes to suggest clumps of leaves. Allow plenty of gaps so that the sky peeks through the foliage. Begin with the light green, and dot in the darker colour towards the left and bottom of each little clump to form shadows. Add dots of lemon yellow near the top of the clumps and allow to blend wet-in-wet, so each clump of foliage has variety of colour and tone.

Add more ultramarine blue and burnt sienna to the darker green to make it even darker, then paint this quickly into the shrubs below the tree, so that they appear to be in shadow. Dot a few darker dabs into the foliage as well.

Repeat this process for the trees on the other side, then the bushes below. Leave to dry.

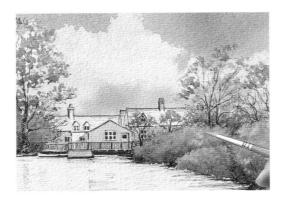

The burnt sienna will warm up the foliage when added to the bushes in places as a light glaze.

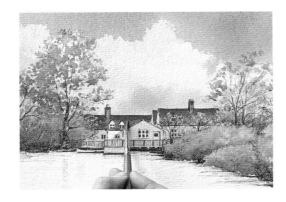

Add more burnt sienna to the middle building to darken it.

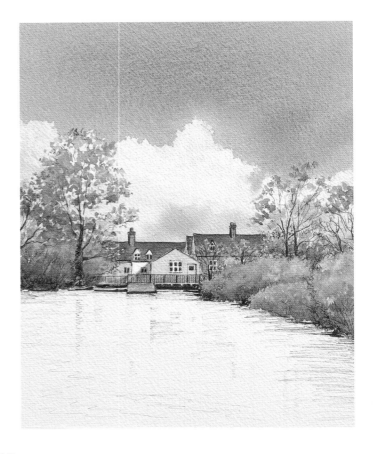

STAGE 3

Mix up some light value burnt sienna, and using the no. 4 round brush, paint the front-facing walls of the buildings with this pale colour. Leave the central one unpainted to create a good contrast and act as a focal point. Still using this burnt sienna mix, glaze over some of the foliage in a few places (see page 23).

When the buildings are dry, create a mid-value mix of burnt sienna and burnt umber, and paint the roofs and chimneys. Add more burnt umber in places to create a weathered look.

Mix a light value grey from ultramarine blue, burnt sienna and raw sienna, then paint the shadow across the white wall as well as the small gable ends of the buildings.

Finally, take some burnt umber and paint the tree trunk and any branches that may look too light. Leave to dry.

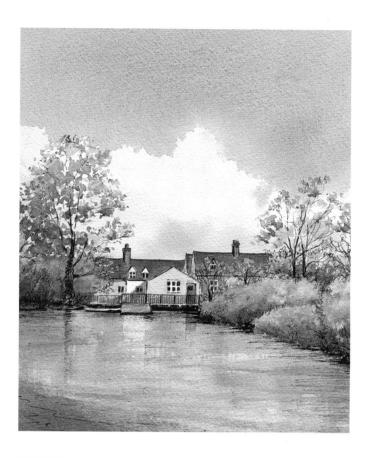

STAGE 4

Mix up more sky colour using cerulean blue and ultramarine. In three separate wells, mix some mid-value raw sienna with a touch of burnt umber, and, if needed, some more of the light green and darker green, using the same mixes that you made at the beginning of Stage 2.

Wet the pond area with clean water using the mottler brush. Paint the sky colour across the bottom and top of the pond with the mop brush, brushing some colour across from the sides below the trees and bushes.

Using the flat brush, pull down vertical brushstrokes of burnt sienna with a touch of burnt umber beneath the buildings; this will create the reflections. Repeat with the green mixes to reflect the bushes and tree.

Lift out a little wet paint with a piece of kitchen paper to create the impression of cloud reflections. Leave to dry.

Once the water is bone dry, use the flat brush to glaze over the shadowy water with light value cerulean blue to brighten the sky reflection. Leave to dry completely.

Use the linework shading as a guide when painting the reflections of the buildings with the flat brush.

The blue glaze acts as a framing device for the bottom of the painting. Spread a little colour through the rest of the water with the tips of the brush.

Bait Diggers at Low Tide

I took this photograph in the late afternoon in February. The tide was out, with the sky and sea a unique and luminous blue-grey beneath the fading winter sun. A group of fishermen walking along the wet sand looking for bait completed the scene.

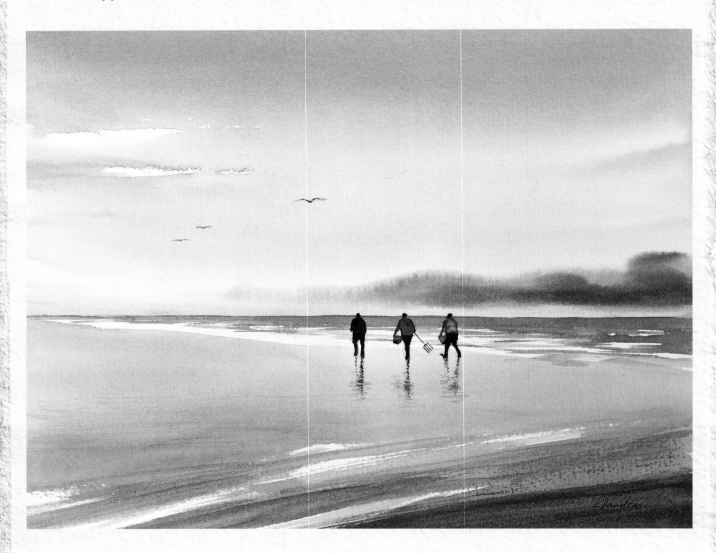

COLOURS NEEDED

Cerulean blue	Lavender blue	Indigo	Cobalt blue	Cadmium red hue	Payne's grey

This scene offers a perfect opportunity to practise painting a graduated wash (see page 23) for the sky and beach, leaving a few unpainted areas in the sky for cloud. The colours of the sky are reflected across the beach, as the wet sand takes on a mirror-like quality which helps emphasize the atmosphere of tranquillity in this scene. The three silhouetted figures of the fishermen with their bright red buckets complete this relatively simple yet compelling painting.

To prepare the preliminary sketch, draw the horizon line just under halfway across the paper, using a ruler to keep things straight. Add a shallow diagonal line below it, to show perspective (see page 19) as the sea disappears into the distance on the left. Place a few sketchy horizontal lines crossing the diagonal to suggest where the sand meets the water.

Pencil in the fishermen, making sure you make the outlines dark enough to see through the wash once it has been painted. Aim to create very simple silhouettes rather than trying for detailed figures.

Add a few sketchy diagonal lines from the right edge of the paper, extending down towards the bottom left to suggest the wet sand.

Tape the paper to your board and set it at an angle of about 20 degrees.

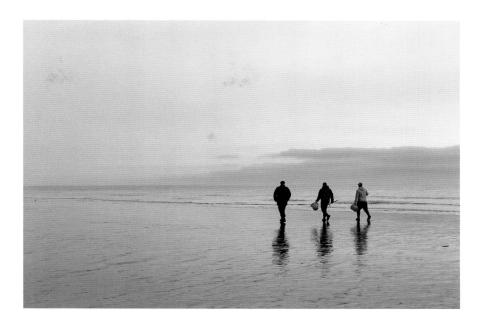

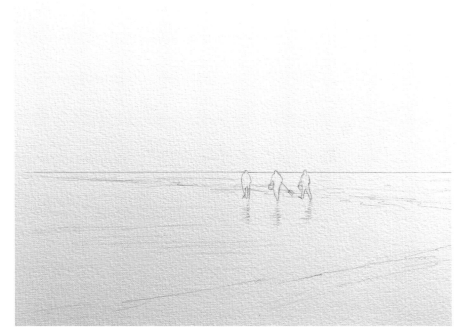

YOU WILL NEED

- *140lb (300gsm) cold pressed (NOT) watercolour paper*
- *HB or B pencil, ruler and eraser*
- *0.3mm waterproof black fineliner pen*

- *Painting board and masking tape*
- *Sponge and kitchen paper*
- *Palette with several large mixing wells*

- *No. 14 mop brush*
- *1½in (38mm) mottler brush*
- *No. 4 round brush*
- *No. 2 rigger brush*
- *¾in (19mm) flat brush*

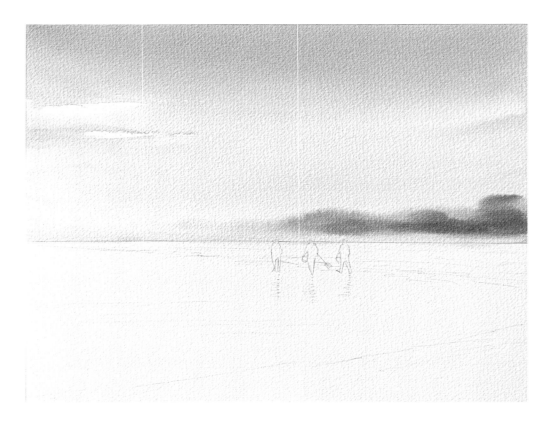

When painting the low cloud, use the side or 'belly' of the brush and make a horizontal brushstroke above the horizon, keeping it flat across the bottom with a cloud-shaped top edge.

STAGE 1

Paint the sky using the wet-in-wet technique. Mix up a large well of mid-value cerulean blue with a touch of lavender blue and indigo. Wet the sky area with clean water using horizontal sweeps of the mottler brush, leaving a few dry strips to suggest cloud. Let it soak into the paper for around 30 seconds, then use a clean damp brush to soak up any water that may have pooled along the horizon line.

Using the flat 'belly' of the mottler brush, paint the sky with horizontal brushstrokes, starting across the top. The paint should start to run thin by the time you reach the dry strips of paper, so it will be paler. If it is still dark, dab the brush on a piece of absorbent kitchen paper to remove some of the paint, then lift the brush slightly so you are now painting with the tip of the brush rather than the belly. Still using horizontal strokes, paint around and into the dry strips, leaving a few unpainted patches for clouds. Continue down to the horizon line.

Quickly add a little more indigo to darken the sky mix. Dip into this with the no. 14 mop brush, making sure to dab the brush onto a piece of kitchen paper to remove excess water so the brush is just damp. Paint a few low, dark clouds just above the horizon.

Take a clean, damp flat brush and sweep the tips horizontally between the grey cloud and horizon to lift some paint to lighten, if needed. Leave to dry.

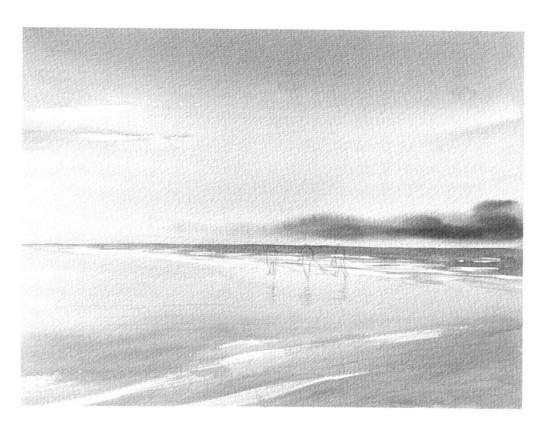

STAGE 2

Using the same blue mix that you used at the end of Stage 1, use the tips of the flat brush to sweep the paint carefully below the horizon line to paint the sea, leaving a few unpainted strips at the water's edge.

Mix up a large amount of the same colour you used for the sky, using mostly cerulean blue with a touch of lavender blue and indigo. Using the 'belly', or flat side of the mottler brush, drag the paint diagonally across the wet sand, leaving some dry brush marks as well as painted paper.

Continue to paint horizontal brushstrokes across the beach, leaving some unpainted paper near the waterline and adding more paint towards the lower edge of the page so the wash becomes darker. Leave to dry.

Paint the sea wider on the right but narrower and paler on the left to show perspective and distance. Lift the brush every now and again to leave little patches of unpainted paper.

Tip
Reduce the angle of the brush to the paper and lightly skim the surface to leave some unpainted, dry brush marks.

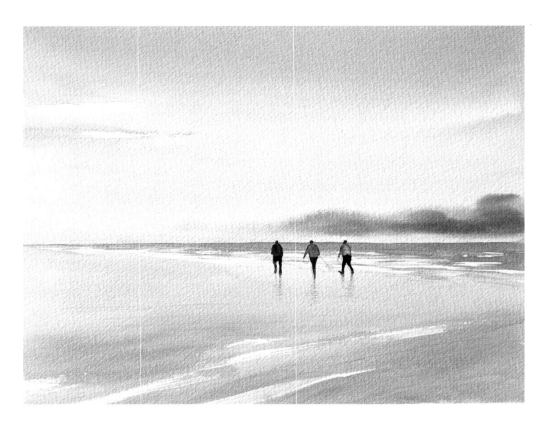

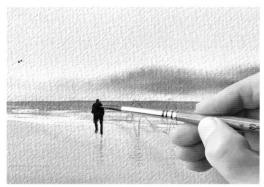

Carefully paint the figures as silhouettes with the tip of the no. 4 round brush.

STAGE 3

The figures are mostly in silhouette, so you don't need much colour. If you are unable to see the pencil outline of the figures through the wash, pencil it in again.

Mix up some dark value indigo and Payne's grey to create a bluish-black. Using the no. 4 round brush, paint the figures. While the middle figure is still wet, carefully dab the jacket with a corner of a piece of kitchen paper to lift the paint, then mix a little dark value cobalt blue to colour the jacket.

Lift out the jacket of the figure on the right in the same way, but leave it pale grey. You could paint it another colour if you prefer, however I like these neutral colours, as it really gives the red bait buckets a chance to pop when added in stage 4. Leave to dry.

Tip
When you have lifted the paint from the jacket, darken the trousers to add contrast.

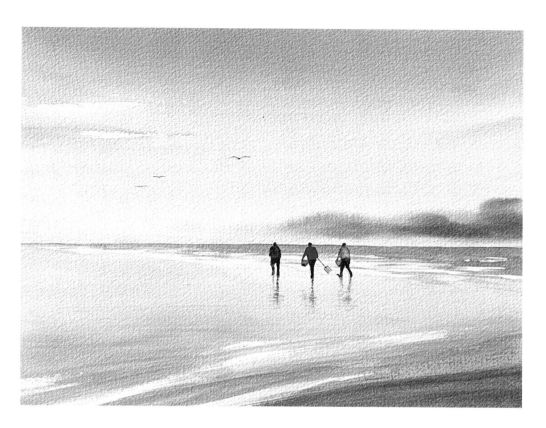

STAGE 4

Use a 0.3mm fineliner to draw the bait digging fork.

Mix some dark value cadmium red hue and, in a separate well, a little mid-value Payne's grey for shadows on the buckets and reflections in the sand.

Using the no. 4 round brush, carefully paint the buckets red. Leave them to dry before adding shadows to the bases and sides, using the Payne's grey.

Once dried, make sure you can still see the pencilled indications of reflections through the wash. If not, lightly draw in again with pencil.

Dip the tip of the no. 4 round into the Payne's grey, dab on a piece of kitchen paper to remove excess paint so it doesn't blob, and add a few little dots and dashes beneath each figure for reflections. Dab any marks that look a bit too big or dark gently with kitchen paper while still wet.

Once these have dried, add a few dabs of cadmium red hue to mirror the position of the buckets in the wet sand. Leave to dry.

Pencil the gulls in lightly, choosing a lighter area of sky so they show up well. Use the 0.3mm fineliner pen to ink them in lightly. Alternatively, you can mix Payne's grey and indigo to create a neutral colour, then paint the gulls in using the tip of the rigger brush.

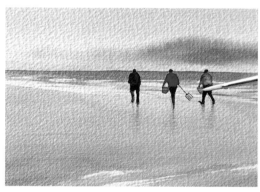

Ensure the figures are dry before adding the red buckets, otherwise the colours will run.

Tip

Before committing them to paper, practise making the birds first to ensure you are confident with painting or drawing them.

Glossary

AERIAL PERSPECTIVE A technique used to add the illusion of depth and distance when drawing or painting landscapes, whereby things become smaller, paler and less distinct as they recede into the background.

ARTISTIC LICENCE Making minor changes or deliberate deviations from the standard form or realism to suit artistic purposes.

BLEND To merge marks or colours together smoothly.

COLOUR PALETTE A chosen set of colours used to create a painting.

COLOUR WHEEL A circular depiction of primary and secondary colours which are organized by their relationship with one another.

COMPLEMENTARY COLOURS Pairs of colours that contrast or 'complement' one another. Traditionally, a primary colour is paired with a secondary colour that is mixed from the other two primaries. For example, blue can be paired with orange, which is mixed from red and yellow.

COMPOSITION The way in which key elements of a painting are arranged so they are artistically pleasing.

CROSS-HATCHING A method of shading that involves layering multiple directional lines at different angles to achieve tone.

GLAZE A thin, transparent layer of paint that is brushed over paint that has already dried.

GOUACHE An opaque type of watercolour paint.

HARD EDGES Paint applied so that the edge of the brushstroke remains crisp, which usually occurs when painting wet-on-dry.

HATCHING A method of shading that is created by using closely grouped parallel lines.

HIGHLIGHTS The lightest part of the painting, often created by preserving the white of the paper through masking, or using white gouache or acrylic ink.

LIFTING OUT A technique whereby paint can be removed to correct mistakes or to lighten certain areas using a brush or piece of absorbent kitchen paper.

LINEWORK The preliminary pencil sketch or ink outlines drawn in preparation for a making a watercolour painting.

LINEAR PERSPECTIVE A technique to create the illusion of depth on a flat surface, whereby all the parallel lines in a painting or drawing converge into a single vanishing point somewhere on the work's horizon line.

LOOSE PAINTING An expressive style of painting that aims more to capture the 'feel' of the subject rather than focusing on detail.

MASKING A technique used to preserve either the white of the paper or protect a layer of paint from subsequent additions of colour.

PRIMARY COLOURS The three colours that cannot be created by mixing other colours: red, yellow and blue.

RULE OF THIRDS A guideline designed to aid composition by positioning points of interest in the upper or lower thirds of the painting, which will help them to appear more visually pleasing.

SECONDARY COLOURS The three colours that can be created by mixing together two primary colours: yellow and blue to create green; red and yellow to create orange; and blue and red to make purple.

SKETCH A rough drawing or painting created to work through the preliminary ideas for a painting; it is used to help create a more polished final picture.

SOFT EDGES Paint applied so that the edge of the brushstroke softens and sometimes disappears, usually occurring when painting wet-in-wet.

SPATTER A pattern of dots and spots created randomly by tapping a loaded paintbrush over part of the painting.

TEXTURE The surface quality of a painting; watercolour paper often has a texture.

THUMBNAIL SKETCHES A series of small preliminary sketches used to test out compositional ideas.

TONAL VALUE The lightness or darkness of tones or colours – in other words, how dark or pale a colour is.

VANISHING POINT In perspective theory, the point at which converging perspective lines disappear on a painting's horizon.

WASH A thin layer of colour created by using watercolour paint diluted with water.

WET-IN-WET A technique for painting directly into a wet surface, which allows the watercolour paint to soften, blend and diffuse on the paper.

WET-ON-DRY A technique for painting directly onto dry paper without pre-wetting it, or for painting onto a wash that has already dried.

Suppliers

UNITED KINGDOM

Lawrence Art Shop
www.lawrence.co.uk

Jackson's Art
www.jacksonsart.com

Ken Bromley Art Supplies
www.artsupplies.co.uk

Cass Art
www.cassart.co.uk

Curtisward Art Supplies
www.curtisward.com

SAA Art
www.saa.co.uk

UNITED STATES

Blick Art Materials
www.dickblick.com

Jerry's Artarama
www.jerrysartarama.com

Cheap Joe's
www.cheapjoes.com

About the Author

Lois Davidson is a watercolour artist from the south-east of England with over 40 years of experience. She has been painting professionally since 2020, and was shortlisted for the Jackson's Painting Prize in 2021. Her creative interests are focused primarily around her local coastal landscapes, from which she draws constant inspiration. She now runs a successful YouTube art channel alongside her daughter, demonstrating traditional and experimental watercolour techniques, with a focus on loose landscape painting. Her art is her way of connecting with overlooked areas within the landscape through the medium of ink and watercolour.

Alongside her painting tutorials, Lois also runs a popular art community online, offering guidance and more in-depth learning opportunities. She has exhibited her work locally, and her paintings have sold around the globe.

For more information, see:
www.loisdavidsonart.com

Acknowledgements

I would like to thank the people who helped make this book possible: my daughter Morgaine Davidson, for her unwavering support and invaluable help in bringing much-needed clarity and order to my artistic ramblings. Sincerest thanks also go to Laurence Horner, Keith Evans and John Horner for their wonderful photographs that kept me inspired, and to the many students of watercolour and fellow artists who have followed my artistic journey online and offered endless encouragement. Many thanks also to Jonathan Bailey for inviting me to pen this book, and to Tom, Robin, Theresa, Jim, Alex, Scott and Jane, the team at GMC Publishing, whose expertise and support have helped turn this vision into a reality; and to Chya the studio cat, who has been my constant companion through many long hours of painting.

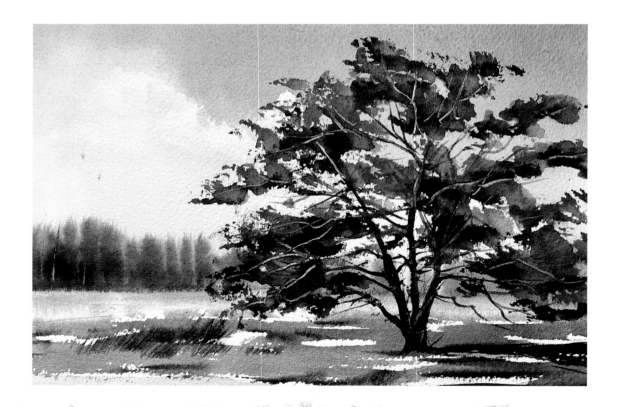

Index

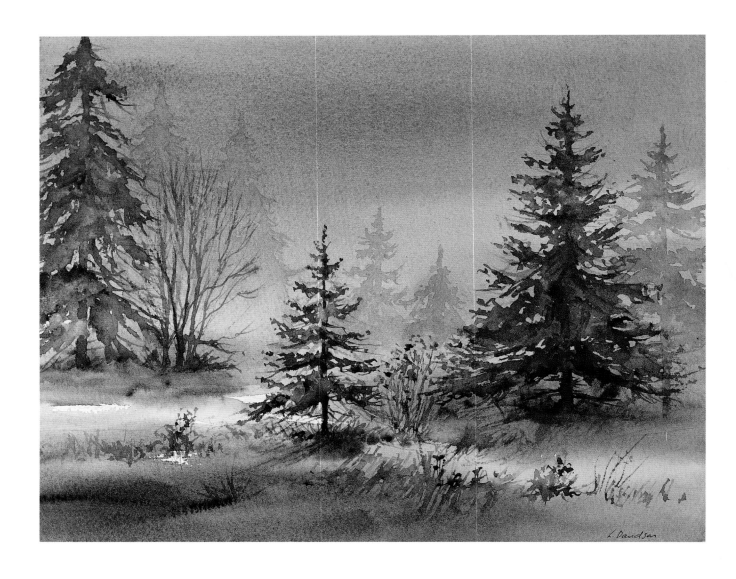

To order a book, contact:

GMC Publications Ltd

Castle Place, 166 High Street, Lewes, East Sussex, BN7 1XU

United Kingdom

Tel: +44 (0)1273 488005

www.gmcbooks.com